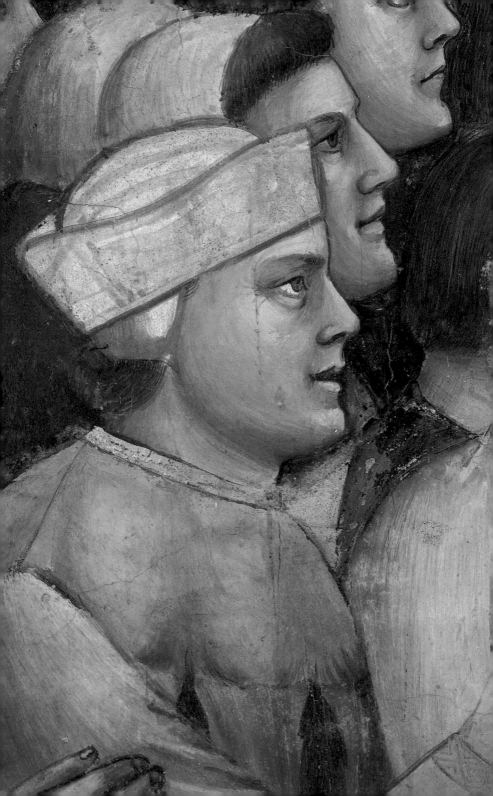

1291–1294

1297–1305

1302–1305

Scenes from the Life of St Francis

From Assisi to Padua

The Arena Chapel

1315–1325

1325–1337

Indexes

Giotto's fame spreads

Late works

Giotto, *The Doctors of the Church* (detail), vault above the high altar, Upper Church, Assisi.

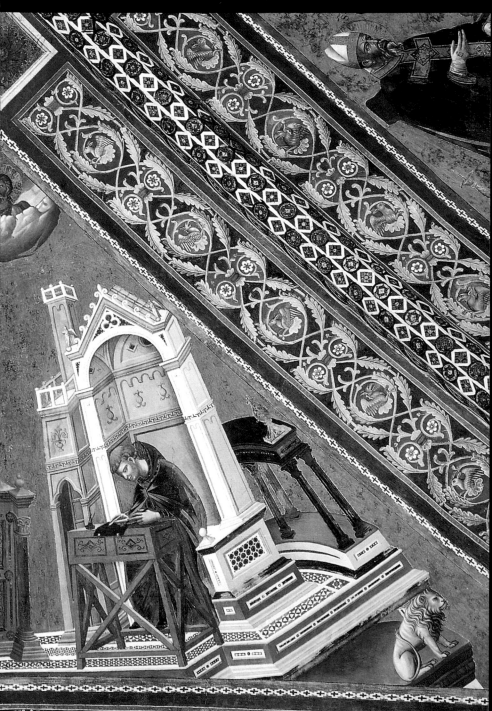

A legend from the beginning

Destined to become one of the most important artists in the history of western painting, Biagio or Agnolo, known as Giotto, was born at Colle di Vespignano in the Mugello valley near Florence in what most scholars date as 1267. There is no documentary evidence to provide us with any certain information about the chronology and events of his life but literary sources and legends abound bearing witness to the fame he enjoyed from the beginning of his artistic career. Until his death in Florence in 1337, his life was spent between the foremost centers of thirteenth- and fourteenth-century Italy, where he absorbed the cultural and artistic legacy of the age and transformed it into a highly evolved and revolutionary language with an originality that is generally regarded as marking the beginning of the history of Italian painting. Giorgio Vasari, author of the first biography of Giotto, confirmed his importance in art. His book is redolent with legend and myth, including the celebrated story of how the artist Cimabue, happening by chance upon the young Giotto drawing on a stone, was so struck by the boy's skill that he took him into his Florentine workshop.

■ The Mugello Valley north of Florence (below) takes in the basin of the River Sieve. The area is made up alternately of flat parts, where vines and olives are cultivated, and hilly sections, which are densely covered with oak and chestnut trees.

■ Drawing by Dévéria, 1845, illustrating the tale told by Vasari of the meeting between Giotto and Cimabue. The artist is depicted as a shepherd for his father, Bondone, was a poor peasant farmer.

■ Opening lines of the *Decameron* by Giovanni Boccaccio from a 1384 manuscript. Biblioteca Laurenziana, Florence.

It was Boccaccio who penned the first appraisal of Giotto's innovative treatment of nature and reality.

Literary sources

The innovative nature of Giotto's art was immediately recognized by the main cultural figures in Italy. Foremost among these was Dante, who, in his eleventh canto of *Purgatory*, bestowed upon Giotto an even higher accolade than Cimabue. Dante's reference in his *Divine Comedy* confirms the genius of these two thirteenth-century figures, both recognized as "fathers" of the Italian tradition, one in language, the other in painting. Giotto's supremacy was also recognized by Villani, Cennini, and Ghiberti.

■ Paolo Uccello, *Five Men's Heads* (detail), Musée du Louvre, Paris. Giotto's portrait is placed next to those of Donatello, Brunelleschi, Antonio Manetti, and Uccello, the founders of Florentine art.

Giotto in Florence

■ Cimabue, *Crucifix*, c. 1268, San Domenico, Arezzo. The powerfully expressive features of Christ set this work apart from the contemplative rigor of its iconographic precedents.

B y the end of the thirteenth century, Florence, in common with other Italian centers, had gradually freed itself from the closed feudal system and now flourished in the new, open vision of the world that was governed by positive and rational thought. This was evidenced by the remarkable economic and cultural development that took place at this time. After his return from a trip to Rome in 1272, Cimabue had gradually introduced a new style into Florentine art in place of the established Byzantine model. This style was based on a new-found three-dimensionalism that was derived from classical art. It is feasible to suppose that Giotto had arrived in Florence in the early 1280s while still very young, and that he remained in close contact with Cimabue during his period of training there. While in the city Giotto would also have been exposed to the powerful Romanesque architecture of the Baptistry and the Basilica di San Miniato, as well as to an emerging Gothic sensibility, visible in the more recent churches of Santa Trinita and Santa Maria Novella.

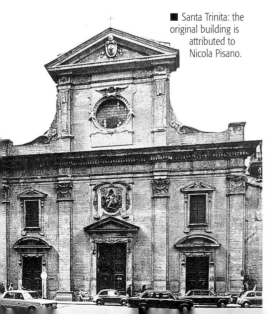

■ Santa Trinita: the original building is attributed to Nicola Pisano.

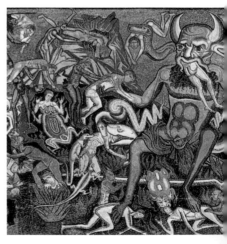

■ Giotto, *The Last Judgment* (detail), 1302–05, Arena Chapel, Padua. This figure of a demon in the lower right section of the fresco below is a reference to a similar figure in a mosaic by Coppo di Marcovaldo in the Baptistry – a sign of the impact Florentine mosaics had on Giotto. Here Gitto manages to express the same sense of the grotesque.

■ Cimabue, *Madonna Enthroned with Angels*, c.1280, Louvre, Paris. Not all scholars attribute this altarpiece to Cimabue, although it clearly shows a desire to move away from Byzantine style in order to achieve a more ample sense of space. This is suggested by the foreshortened throne and the surrounding angels, situated behind one another to create a sense of depth.

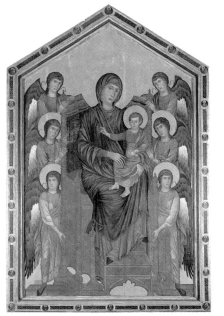

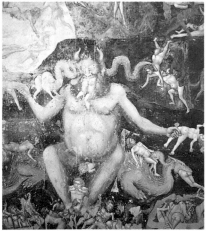

■ Coppo di Marcovaldo, *The Last Judgment* (detail, left), 1260–70, Baptistry, Florence. These mosaics are crucial in order to understand Florentine draughtsmanship before Giotto.

■ The church of Santa Maria Novella, from the view of Florence known as *Pianta della Catena*, attributed to Francesco Rosselli, 1492. Museo Storico-topografico, Florence.

11

1267–1290

Madonna and Child

In 1965 the "Capolavori e Restauri" (Masterpieces and Restorations) exhibition held in Florence attributed this work to Giotto. The painting was found in the parish church of Borgo San Lorenzo, near Florence, and is said to be his earliest work.

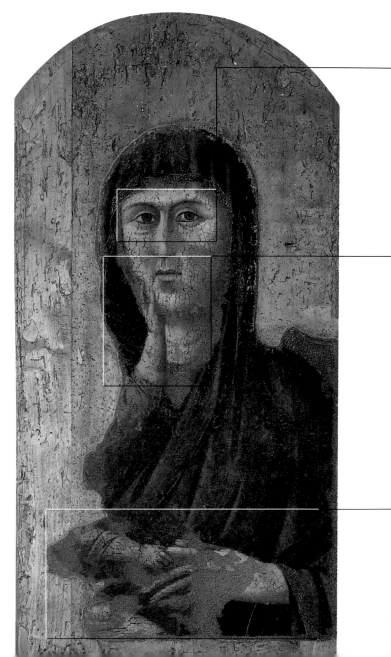

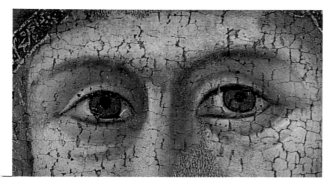

■ Despite the painting's poor state of repair, the Madonna's face appears to derive from Cimabue's style. Framed by a veil, her intense expression is characterized by her elongated eyes that gaze directly at the viewer.

■ The figure of the Child, unusually placed on the left of the Madonna, has been lost; only the arms are visible, which suggest an animated and affectionate child rather than one who is portrayed from the front in a pose of being blessed, as in the pre-Giotto School tradition. One arm reaches upward as if to stroke the mother's face, while the other stretches into the foreground, the hand affectionately clasping that of the Madonna. Such a pose is far removed from the fixed, solemn stance more usually associated with the Madonnas that date from this period, suggesting the artist's keen interest in expressing human sentiment. These gestures herald the "poetry of feelings", which is characteristic of Giotto's work. The panel reveals a certain dependence on Cimabue and indeed, could even indicate it was by a disciple of the master.

1267–1290

Tuscany

In thirteenth-century Tuscany, cities such as Pisa, Siena, Pistoia, and Florence consolidated their political and economic situation to achieve a level of stability and security that enabled each to develop its own individual artistic tradition. This placed Tuscany in a position of undisputed cultural supremacy. Building work on the cathedral in Pisa – a proud maritime republic – was begun in 1063 by Buscheto and then continued by Rainaldo. As an inscription on its façade relates, the cathedral, situated in the center of the famous square known as the Campo dei Miracoli, was built with finances from the loot seized in a victory over six Saracen ships. Thus the historical and political relationship with the Orient also became a vehicle for a style that found its greatest expression in the cathedral. Pisa was also a base for Nicola Pisano who developed a school of sculpture that was broadly European in character, translating three-dimensional elements into a solid and expressive figurative language, which Giotto would come to adopt in his work. Artistic sensibilities in the city of Siena, on the other hand, were animated by the elegant, luminous qualities of Duccio da Buoninsegna's work, in which color and light determined the suppleness of his figures.

■ The round outline of the Baptistry, designed in 1153 by Diotisalvi, dominates the Campo dei Miracoli in Pisa, in the center of which stands the cathedral and the cylindrically-shaped Leaning Tower.

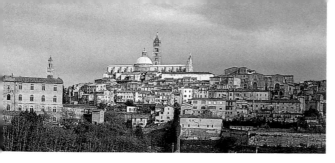

■ A view of Siena today, seen from the hill of San Prospero.

■ Stained-glass window in the choir of Siena Cathedral showing the *Assumption of the Virgin*, built in 1287–88 to a design by Duccio da Buoninsegna. The craftsman who created this window skilfully succeeded in translating the richness of Duccio's colors into the stained glass medium.

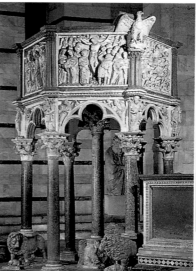

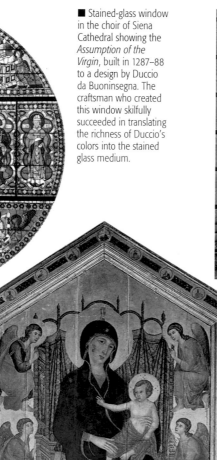

■ Nicola Pisano, pulpit, 1255-60, Baptistry, Pisa. Pisano created this pulpit using a highly successful innovative structure. The six panels are arranged in a rhythm that is already Gothic in character, yet still treated in a classical manner.

■ Duccio di Buoninsegna, *Rucellai Altarpiece*, 1285, Uffizi, Florence. The certain attribution of this work to Duccio is due to the novel treatment of space and the echoes of perspectival elements that are Byzantine in taste.

15

Rome

■ Giotto?, *Crucifix*, Palazzo Venezia, Rome. Although its color has almost completely faded, this crucifix, originally in Santa Maria in Aracoeli, has also been attributed to Giotto because of the way in which Christ and St John have been drawn.

Giotto's first journey to Rome appears to have been very important in his artistically formative years. In the city of Rome, which was under the pontificate of Nicholas III Orsini, the arts flourished during this time in a climate determined to affirm the political and religious primacy of the papacy through the work of builders, sculptors, and artists including Cimabue himself, accompanied perhaps by his most gifted pupil, Giotto. Giotto was inspired by the mighty architecture of the city, deriving from its grandiose buildings the classical structure that would come to characterize his work. He also adapted stylistic features and elements from the painters Pietro Cavallini and Jacopo Torriti of the Roman School, but it was Arnolfo di Cambio who encouraged Giotto to develop a language that would express a synthesis between classical power and Gothic dynamism.

■ Giotto?, *Prophet*, one of a series of prophets in a frieze at Santa Maria Maggiore, Rome.

■ Arnolfo di Cambio, ciborium, 1285, San Paolo, Rome (right). Arnolfo was active in Rome from 1275; his work displays classical elements borrowed from the school of Nicola Pisano.

■ *Nicholas III Offering the Model of the Sancta Sanctorum*, 1277–80, Sancta Sanctorum Chapel, Rome (above). This chapel was commissioned by the pope to house the more valuable relics; it is one of the most magnificent examples of medieval decoration in Rome.

■ Cimabue, *Rome* (detail), Basilica di San Francesco, Upper Church, Assisi. This fresco, part of the *Four Evangelists* in the vault of the choir, is one of the oldest pictures of Rome. The city can be identified by landmarks such as the Campidoglio and the Pantheon.

Crucifix

Some critics date this as being painted just before *Scenes from the Life of St Francis*, others place it immediately after. Housed in the church of Santa Maria Novella in Florence, this work is remarkable for its utterly innovative iconographic portrayal of Christ.

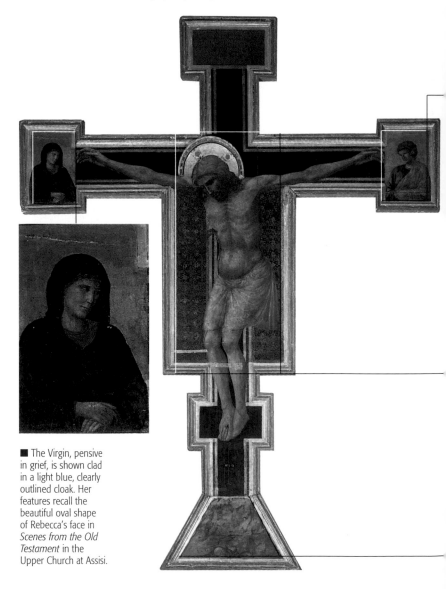

■ The Virgin, pensive in grief, is shown clad in a light blue, clearly outlined cloak. Her features recall the beautiful oval shape of Rebecca's face in *Scenes from the Old Testament* in the Upper Church at Assisi.

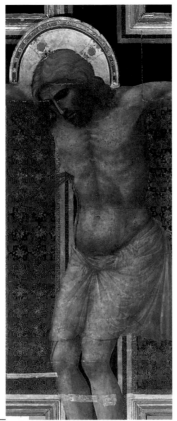

■ The side panels showing *St John* and *The Virgin* are the most traditional features of the *Crucifix*. St John is powerfully drawn in pink and light blue robes, which are strongly delineated. He is stylistically similar to those figures in the frescoes at Assisi illustrating scenes from the Old Testament. Quite apart from these stylistic considerations, the Santa Maria Novella *Crucifix* is a work of extraordinary originality and artistic merit.

■ Some elements make this portrayal of Christ radically different from anything that had gone before. The halo, like his legs, is kept within the outline of the cross, making the painted wooden support an autonomous feature. The anatomy of the body does not have three defined parts as does Cimabue's *Crucifix*, but rather it is modelled along classical proportions, slightly inclined towards the right and delicately rendered in chiaroscuro. Christ's nailed hands hint at spatial depth, while his perfectly proportioned head, framed by shoulder-length hair, expresses the human sorrow he experienced.

■ The bottom of the panel depicts *Golgotha*. Adam's skull, a symbol of humankind's redemption by Jesus' sacrifice, can be glimpsed between a gap in the rocks. This theme is a new element in portrayals of the Crucifixion, creating a specific iconography of its own.

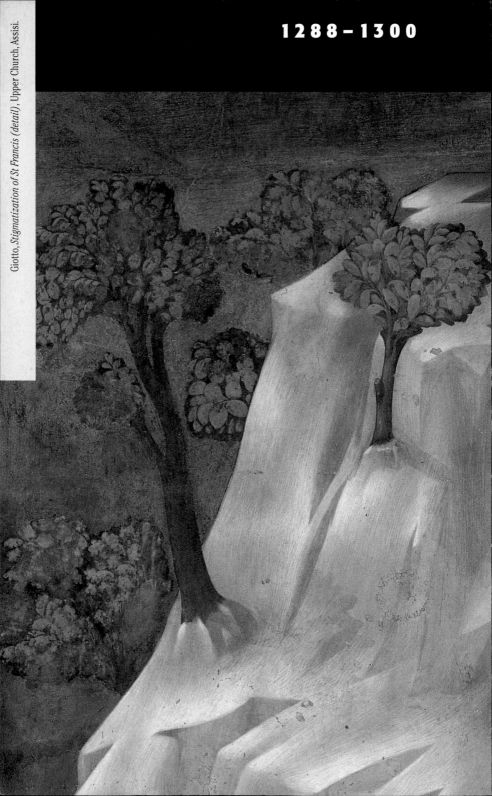

Giotto, *Stigmatization of St Francis (detail)*, Upper Church, Assisi.

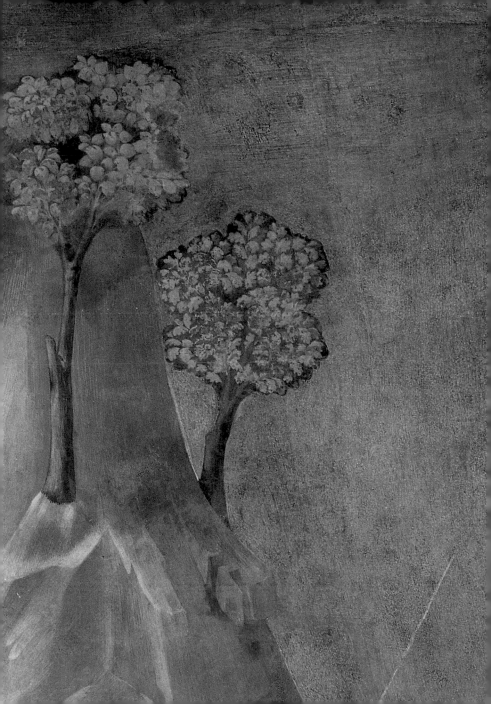

The Basilica di San Francesco

The cornerstone of the Basilica di San Francesco at Assisi was laid by Pope Gregory IX on July 17, 1228, a day after a solemn ceremony that marked the saint's canonization. The building of the basilica was the result of both the pope's wish for such a temple to be established, which would be a statement of his fondness for Francis and the order of friars which the saint had founded, and a way for the friars themselves to honor their founder. Gregory IX granted indulgences to those who had contributed to the building of the church through alms and donations, enabling the work to proceed rapidly and in the most grandiose manner. The site chosen was the western slope of Mount Asio, known as "colle dell'Inferno" (the hill of hell), named in memory of executions that had at one time taken place there. It was handed over to Elias, the prior of the order, on the condition that the church house the remains of St Francis (transferred there in 1230.) The rocky, steep terrain accounts for the unique character of the building, which is arranged on two levels, each being an autonomous place of worship different from the other in structure and concept. Historically, the church came to be built at a particularly propitious time, benefiting from a truce in the conflict between the papacy and the empire, evidenced by the cordial relationship between Frederick II of Swabia and Elias. Their names, together with that of Gregory IX, are engraved on the bell at Assisi, so setting the seal on a common agreement between them.

■ Assisi lies on the northwestern slope of Mount Subasia in the heart of Umbria. The town dominates the surrounding area, which is made up of fertile countryside and thick woods. Its location, as well as its history, has determined the town's significance as a symbol of Christian and ecumenical spirituality.

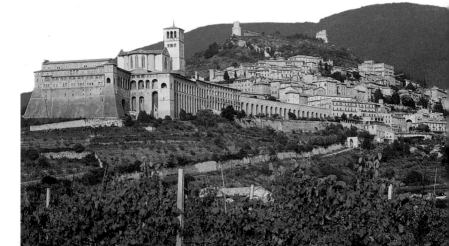

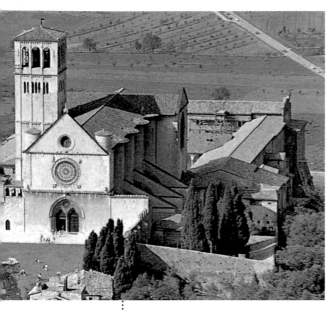

■ The Upper Church has a single nave divided into four, with a transept and apse. The simple façade, with its large rose window, is typical of the Umbrian Romanesque style. The pointed double portal, on the other hand, is derived from the northern Gothic manner.

■ A view of the interior of the Lower Church. Resembling a large crypt, with strong Romanesque outlines, the dark Lower Church is totally covered in frescoes.

Gothic features in the Basilica di San Francesco

The Basilica di San Francesco played a vital part in the evolution of Italian Gothic and is one of the most important buildings constructed in this style. Space spreads out in all directions, free of the restrictions imposed by naves. The vaulting ribs rise to the top, giving the building a dynamic sweep. Light comes through enormous windows, animating the colors of the frescoes.

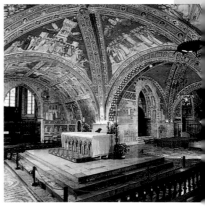

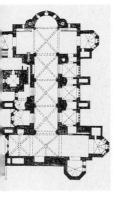

■ A plan of the basilica reveals the complexity of its structure: the building is arranged on two levels because of the nature of the terrain. The Lower Church is based on the Tau cross structure favored by St Francis, whereas the Upper Church is a vast Gothic hall, completed by a wide transept.

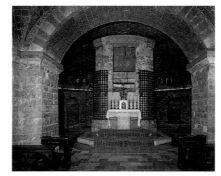

■ The tomb of St Francis (left). After several attempts were made to desecrate the saint's remains, the tomb was walled up in 1476. Now a popular pilgrimage site, St Francis' stone coffin is also protected by an iron grille.

23

1288–1300

The Doctors of the Church

Begun in 1275, these four sections, which portray the first four doctors of the church, are part of the rich decoration of the vault above the high altar in the Upper Church at Assisi. They are attributed to Giotto.

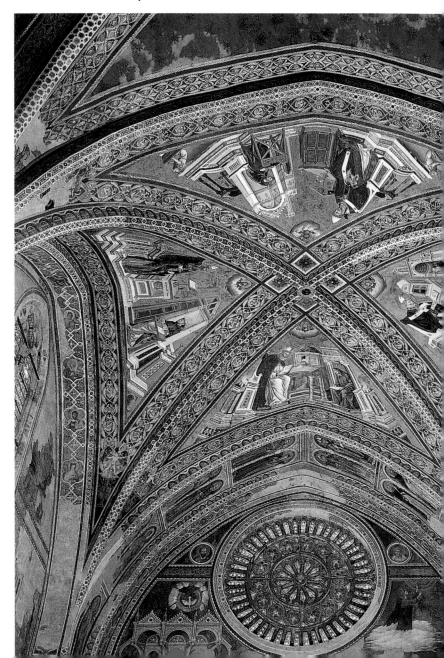

■ The two pictures below show the damage caused by the earthquake of September 1997. A violent tremor completely destroyed one of the quadrants, part of the underside of the arch and part of the *Four Evangelists* vault by Cimabue. In the vault dedicated to Gregory the Great, Giotto presented a much wider and freer concept of space than can be seen in the other vaults.

■ *The Doctors of the Church* stands out from the other vaults with its dazzling use of color, the monumentality of its figures, and the spatial area in which these portraits are set. Each section is framed by exuberantly decorative geometric, figurative, and floral motifs. The doctors are shown dictating or reading to a deacon who faces them. Each figure sits on a throne, which has been created with inlaid colored stone and glass to create a mosaiclike effect. These thrones define the space of the composition both as a whole and in relation to each figure.

25

Other artists in the Upper Church

Many artists were called upon to work on the nave of the Upper Church. Of the different contributors commissioned, all adhered to a harmonious iconographic scheme which had its starting point in the presbytery. Scholars have had a difficult task in attributing and dating the many painted works although current opinion suggests that the decoration was conducted by a few main artists, helped by a number of assistants. The oldest work is by the so-called Maestro Oltremontano, to whom part of the northern transept is attributed. Easier to identify are a few frescoes from the Roman School, including some by Jacopo Torriti to whom the magnificent *Saints* vault is attributed, as well as the frescoes in the upper tier of the first two bays. The most important contribution before Giotto's, however, was that of Cimabue, who was probably active under the pontificate of Nicholas III. He created supreme examples of pre-Giottesque painting, in which Byzantine elements combine with the tragic and intense expressive style of Gothic art.

■ Cimabue, *Four Evangelists* (detail), after 1278, Upper Church, Assisi. The vault shows the Evangelists, each seated before a city.

■ Giotto, *Lamentation* (detail), Upper Church, Assisi. The fresco reveals a modern, powerful language, similar to that employed in the *Scenes from the Old Testament.*

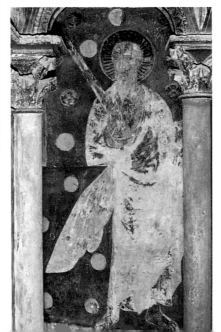

■ Maestro Oltremontano, *St Paul*, Upper Church, Assisi. This, one of six figures of saints and prophets all statuesque in appearance, is attributed to an artist who can only be identified as a master working in the Alpine region. It is believed that he was commissioned by Pope Clement IV who, having been helped by the French troops of Charles of Anjou in defeating the Swabians at the battle of Benevento (1266), wanted to honor his debt of gratitude to France through these frescoes.

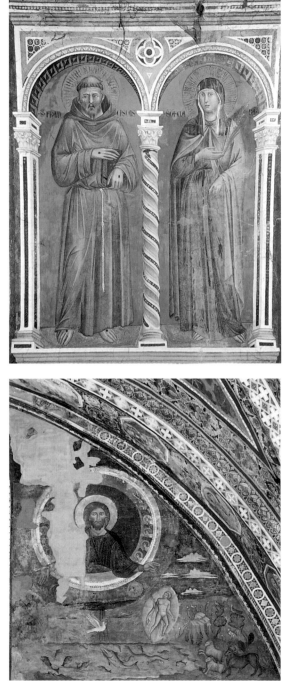

■ Giotto and Memmo da Filippuccio, *St Francis and St Clare*, Upper Church, Assisi. This series of saints on the underside of the vault showing *The Doctors of the Church* can be attributed to a Sienese artist as well as Giotto. St Clare, delicately drawn and standing slightly at an angle in an elegant pose, was possibly drawn by Memmo di Filippuccio, a major Sienese painter whose work after the Assisi cycle displays elements of Giotto's influence.

■ Jacopo Torriti, *The Creation*, Upper Church, Assisi.

27

MASTERPIECES

Isaac Rejecting Esau

The two scenes depicting Isaac, painted on the right-hand wall of the third bay, represent one of the finest achievements in the decoration of the Upper Church. Critics tend to attribute them to Giotto.

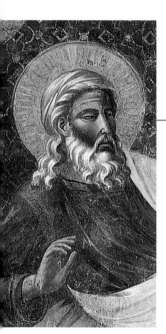

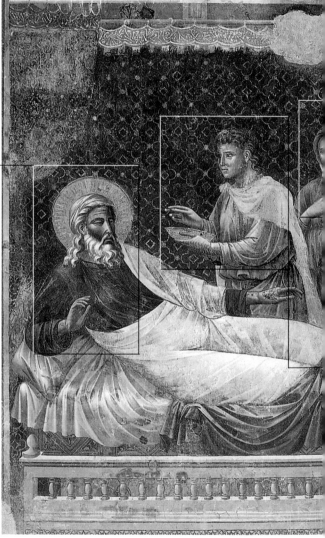

■ Isaac's head, crowned by a halo, stands out clearly against the background drapery. His eyes are half-closed from blindness and his expression is grave and solemn, typical of the manner of figures in classical reliefs. Isaac's face, made more realistic by the inclusion of wrinkles, is highlighted by a skilful use of chiaroscuro.

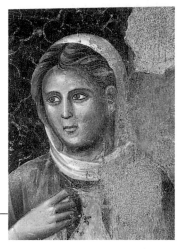

■ In the background Rebecca holds back a little, a position that gives the scene spatial depth and increases the viewer's interest in the narrative. Her head is tilted gently to the left and her expression is rapt and vigilant, revealing some reservations about the deceit that has just been perpetrated. The sense of reality in this work is very strong, and due care is given to the psychological content.

■ The figure of Esau, like the others, is solidly developed, defined by his beautiful, confidently painted cloak with its interplay of light and shade. The central character of this episode, Esau is placed in the middle of the scene and so adheres to a compositional and narrative order that recurs throughout the Assisi frescoes.

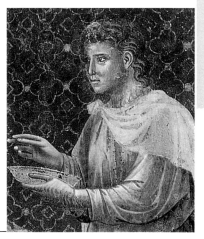

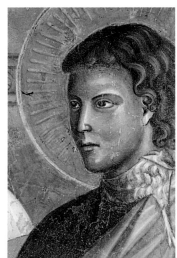

■ Giotto, *Isaac Blessing Jacob* (detail). The second episode depicting Isaac is in a poor state of repair. Only the head of Jacob and his halo have been well preserved. His features recall those of his brother Esau in the previous episode. Jacob wears a sheepskin, glimpsed beneath his clothes, to mimic Esau's hairy body – "like a hairy garment" – and fool his father into bestowing his blessing on Jacob.

29

Fresco techniques

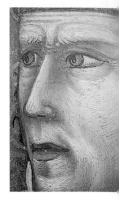

Giotto's *Scenes from the Old Testament* reveal a change in his artistic expression, achieved by means of a new relationship between the figures and the space surrounding them, and an awareness of volume. They also mark a turning point in fresco techniques. Giotto rejected the existing *a pontata* technique, whereby large sections of the wall were plastered, in favor of a new, so-called *a giornate* system that involved working on small sections, sufficient for a day's work. All subsequent mural painting would follow this system. Cennino Cennini described this process at the end of the fourteenth century in his *Libro dell'Arte (The Craftman's Handbook)*. The *a giornate* method consists of transferring a drawing on a cartoon onto the painting surface (intonaco); this drawing, touched up with red iron oxide pigment, then becomes the so-called sinopia. At this point, the artist works on sections that he can comfortably complete within the same day. Having moistened the plastered surface, which has to be kept wet until the final application of color, he then applies the thin, smooth intonaco and transfers the drawing onto this. The drawing has to be colored before the plaster dries. It took Giotto 546 days to produce the St Francis cycle in Assisi. His progress appears to have been determined by the narrative sequence and the organization, which was governed by technical considerations.

■ The flesh tones vary from figure to figure, according to fresco methods classified by Cennini and identified during recent studies. The face of Honorius III in *St Francis Preaching before Honorius III* illustrates one of these methods. The face is characterized by thin, interconnected brushstrokes that pick out details.

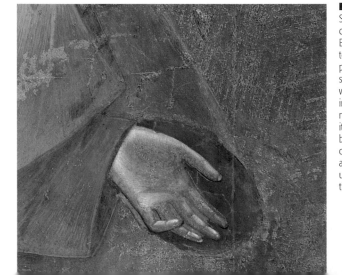

■ The left hand of St Francis would have constituted a day's work. Examining the cycle in terms of individual painting sessions of single days provides us with a useful technical insight into the working methods employed in its execution. This background knowledge of history and technique also deepens our understanding of the work.

■ Outlined in these two episodes from *Scenes from the Life of St Francis, Miracle of the Spring* and *St Francis before the Sultan (Trial by Fire)* is the subdivision of each section into separate day-long working sessions. Giotto's method was to work on the upper part of a scene in a single, long day, completing the lower section, which included the figures, over several days. We can speculate that he worked from top to bottom in horizontal bands, a system which would have prevented the paint from running and enable him to work on one or more scenes at the same time.

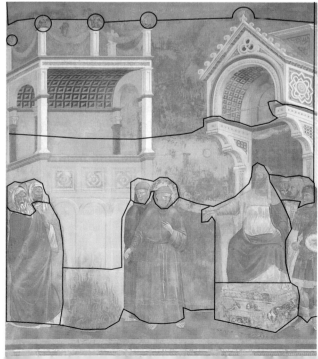

LIFE AND WORKS

Nature and objects

"He was so unique a genius that there was nothing in nature, the mother of all things and the reason why the world keeps turning, that he could not reproduce with his pen or paintbrush in so lifelike a manner that one might think that it was not merely very like nature but was nature itself." Giovanni Boccaccio, in 1350, a little more than ten years after Giotto's death, thus acknowledged the extraordinary quality of his work and his skill in reproducing elements of nature so well that they appeared more realistic than they did in real life. This opinion holds the key to our whole appreciation of Giotto. Through him the world of concrete objects, which until then had only been viewed as having a symbolic function, came to acquire a new meaning. In this, perhaps, lies the most revolutionary element of Giotto's work. The transition from an essentially abstract representation, which could only be interpreted by means of faith, towards an art form that also rested on the observation of nature, was already underway in Gothic sculpture outside Italy, particularly in Chartres and Reims, but it was at Assisi, in the *Scenes from the Life of St Francis* that painting, too, began to read events in historical terms and thus, by extension, within a human and earthly context. Giotto's portrayal of animals and plants, flowers, pottery, rocks, and carpentry tools captures the intrinsic value of each object, which is its role in history.

■ Giotto, *Stigmatization of St Francis* (detail), Upper Church, Assisi. Giotto includes the flower detail within the rocky landscape for its symbolic value, at the same time revealing a keen eye for observation.

■ Giotto, *Miracle of the Crucifix* (detail), Upper Church, Assisi. By showing the beams supporting the roof of the church of San Damiano, Giotto reveals his interest in building techniques and in the woodwork of the roof, right down to its very nails.

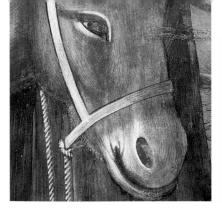

■ Giotto's handling of animals is as meticulous as his portrayal of human figures, no doubt driven by a keen sense of enquiry and in a spirit of sharp observation. The donkey's head in *Miracle of the Spring*, which is simply and unelaborately bridled, is rendered in precise yet naturalistic detail, as well as in suggesting the animal's subjugated attitude. In *Sermon to the Birds* Giotto skilfully captures the mobility and plumage of the feathered creatures surrounding the saint.

■ In *Death of the Knight of Celano* the table is laid with dishes, bowls, and food, which create a veritable still life, pointing to Giotto's interest in matters of everyday life.

■ In the landscapes which form the background setting to many scenes in the St Francis cycle, Giotto almost always depicts barren high ground covered in rocks, out of which sprout bushy but slender-stemmed little plants, depicted in a traditional way.

33

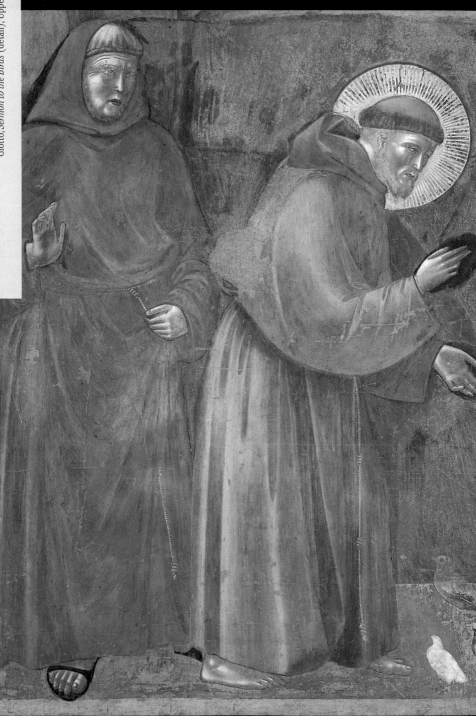

Giotto, *Sermon to the Birds* (detail), Upper church, Assisi.

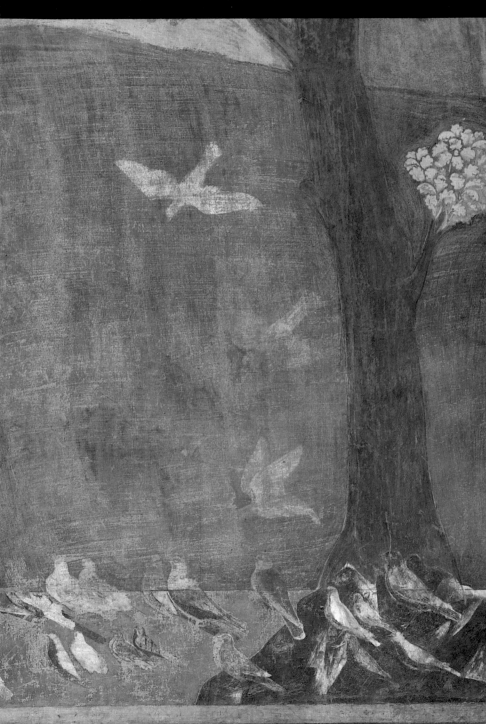

Plan of the frescoes in the Upper Church

■ 1 *Isaac Blessing Jacob*, 2 *Isaac Rejecting Esau*, 3 *Joseph Cast into the Pit by his Brothers*, 4 *Joseph and his Brethren*, 5 *The Death of Abel*, 6 *The Doctors of the Church*, 7 *Road to Calvary*, 8 *Baptism of Christ*, 9 *Christ among the Doctors*, 10 *Lamentation*, 11 *Resurrection*, 12 *Pentecost*, 13 *Ascension*, 14 *St Paul*, 15 *St Peter*, 16 *Angel*, 17 *Madonna and Child*, 18 *Angel*, 19 *Homage of a Simple Man*, 20 *St Francis giving his Mantle to a Poor Knight*, 21 *Dream of the Palace*, 22 *Miracle of the Crucifix*, 23 *Renunciation of Worldly Goods*, 24 *Dream of Innocent III*, 25 *Confirmation of the Rule*, 26 *The Vision of the Flaming Chariot*, 27 *Vision of the Thrones*, 28 *Exorcism of the Demons at Arezzo*, 29 *Trial by Fire*, 30 *Ecstasy of St Francis*, 31 *Institution of the Crib at Greccio*, 32 *Miracle of the Spring*, 33 *Sermon to the Birds*, 34 *Death of the Knight of Celano*, 35 *St Francis Preaching before Honorius III*, 36 *Apparition at Arles*, 37 *Stigmatization of St Francis*, 38 *Death and Ascension of St Francis*, 39 *Apparition to Fra Agostino*, 40 *Verification of the Stigmata*, 41 *St Francis Mourned by St Clare*, 42 *Canonization of St Francis*, 43 *Dream of Gregory IX*, 44 *Healing of the Man of Lerida*, 45 *Confession of the Woman of Benevento*, 46 *Liberation of Peter the Heretic*.

The majestic layout of the *Scenes from the Life of St Francis* at Assisi is exceptional in art history for its narrative breadth, which is not confined to the portrayal of isolated, miraculous episodes in the life of the saint as had been the custom in eleventh-century art, but rather charts his life as a whole in a monumentally orchestrated work. Events in the saint's life are interwoven with events in the life of Christ. The St Francis scenes are related in 28 panels, subdivided into groups of three, painted in the lower part of the nave and thematically echoing the *Scenes from the Old and New Testament* in the two upper parts. St Francis' life thus appears as a kind of *imitatio Christi.*

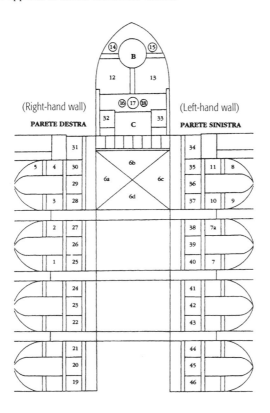

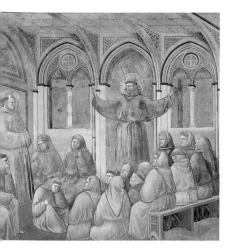

■ *Apparition at Arles.* This episode is shown together with a further three which refer to the legacy of prophetic spirit and the power of preaching handed down to the friars. Francis is likened to Jesus, and bears the stigmata.

■ *St Francis Mourned by St Clare, Canonization of St Francis,* and *Dream of Gregory IX,* confirm the acknowledgment by the church of Francis' sanctity, recognized by his contemporaries and endorsed by his miracles.

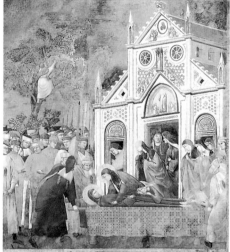

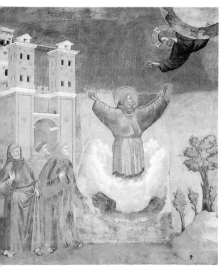

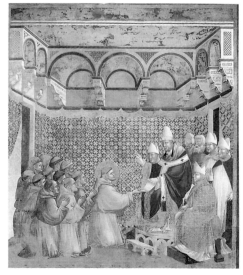

■ The *Ecstasy of St Francis* is painted in the entrance bay in which four episodes are shown. St Francis draws strength from praying to Christ, who becomes Incarnate in the crib (*Institution of the Crib at Greccio*) and restores peace to Arezzo (*Exorcism of the Demons from Arezzo*), and to the infidel (*St Francis before the Sultan [Trial by Fire]*).

■ *Confirmation of the Rule.* Having obtained the pope's blessing, St Francis becomes a new Elijah (*The vision of the Flaming Chariot*) and can aspire to heaven's glory (*Vision of the Thrones*). Corresponding to this trio of scenes, in the upper section of the wall, is the story of Jacob securing his birthright.

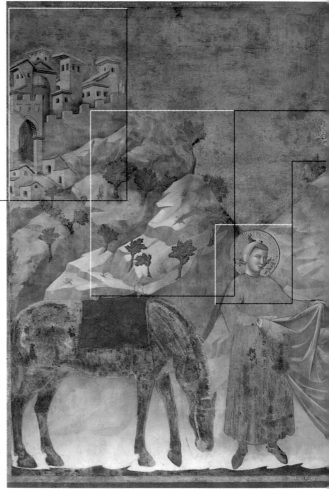

1291–1294

St Francis Giving his Mantle to a Poor Knight

One of the best-known scenes in the cycle, and probably the first to have been painted, shows St Francis removing his mantle in order to give it to a poor knight. The treatment of space, with two parallel levels, is not yet fully evolved.

■ The little town set on the rocky high ground has been commonly identified as Assisi. It is certainly a medieval settlement, enclosed by crenellated walls, with a gate connecting it to the surrounding countryside. Giotto uses perspective to convey the buildings in the background, clearly marking out volumes and grouping them together into a three-dimensional whole.

■ Inspired by the countryside of Umbria, the background is painted along two diagonal lines that converge in the center. Here too, as in other scenes, the landscape is mainly barren, enlivened by small, gnarled trees with wind-blown tufts, which appear to be olive trees.

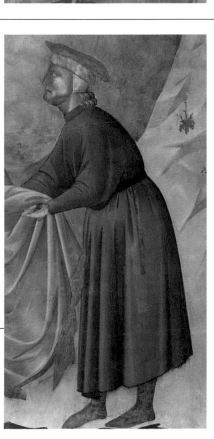

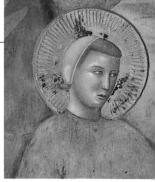

■ The head of St Francis marks the focal point of the composition, placed at the point where the two diagonal lines of rock converge. This implies the central role played by the saint in securing salvation.

■ Giotto has given his drawing of the poor knight, shown bending forward to receive the gift, a sense depth and volume although his features features remain typically stylized.

39

St Bonaventure on St Francis

Between 1260 and 1263 St Bonaventure of Bagnoregio wrote his *Legenda Maior*, the biography of St Francis on which the iconography of the Assisi fresco cycle is based. This work, the official voice of the Franciscans, aims to exalt the order's founder and, in keeping with the Franciscan desire to disseminate knowledge which is typical of its culture, the narrative is couched in simple language. St Bonaventure was inspired by the oral tradition surrounding the saint's life, as well as by previous biographies, and portrays St Francis as a man who is simple in demeanor but resolute in his actions, driven by his love for God from which he derives his spirit of charity towards his fellow man and all creatures. Bonaventure himself outlines the criteria he adopted in writing the work: "I have not always told the story in a chronological way... I felt I should rearrange events that took place at the same time according to themes." The biographer's intention, clearly, was not to provide a chronicle or even a biography of the saint: by identifying St Francis with the angel of the sixth seal of the Apocalypse, he wanted to give him a particular vocation in the history of salvation. This function is borne out by the circular painting of the third section where St Francis is shown as intermediary between God and humanity.

■ Francis' habit (below), preserved in the Chapel of Relics in the Lower Church, provides eloquent evidence of the lifestyle chosen by the saint. Made of rough goat's wool, coarsely woven, it bears witness to a radical rejection of even the slightest concession to wordly comfort.

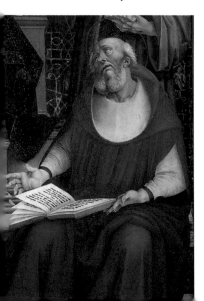

■ Luca Signorelli, *Madonna and Child Enthroned with Saints* (detail, *St Bonaventure*), Pinacoteca di Brera, Milan. St Bonaventure of Bagnoregio, born in 1221, minister general of the Franciscan order from 1257, is viewed as one of the most highly-regarded philosophers and theologians of the Middle Ages and was frequently represented as such in art.

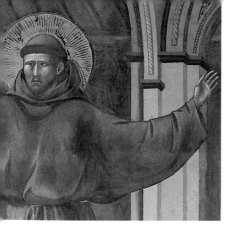

■ Giotto, *Apparition at Arles* (detail), Upper Church, Assisi. St Francis, shown from the front in this scene, reveals a full face, a tonsure, and a short beard.

■ Cimabue, *Maestà* (detail), Lower Church, Assisi. This picture of St Francis is to the right of the Virgin's Throne. The features echo the description of the saint by Tommaso da Celano.

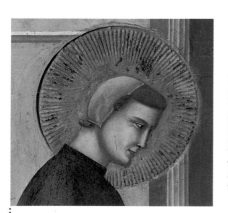

■ Giotto, *Homage of a Simple Man* (detail, left), Upper Church, Assisi. Here St Francis has a youthful aspect and is shown without a tonsure. This head would have taken an entire day's work to complete.

■ Giotto, *Confirmation of the Rule* (detail), Upper Church, Assisi. Here the face of St Francis is intensely expressive, focused and resolute in the solemnity of the moment.

The iconograpy of St Francis

Tommaso da Celano, the first biographer of St Francis, described the saint as "... not very tall, with an even, rounded head, an oval, somewhat protruding face, a small, flat forehead, dark eyes that were normal and simple, and hair that was similarly dark." This vivid description is often echoed in representations of the saint, such as the fresco in the Sacro Speco at Subiaco, painted while he was still alive. A contemporary element thus crept into sacred painting, which explains the lively, immediate quality of the saint's image and the events of his life, which were not linked to a sacred biography but set in the streets of Assisi, among the people of Umbria.

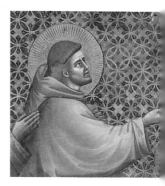

Giotto's version

The attribution of the St Francis cycle at Assisi to Giotto is still being debated by art historians. The doubt arises from the absence of specific documentation that could determine the answer. Giotto's presence in Assisi is first mentioned by Riccobaldo Ferrarese in his *Compilatio Chronologica* of 1312–13 but it was Vasari, in the second edition of his *Lives of the Artists*, in 1568, who named Giotto as the artist responsible for the frescoes. His hypothesis is mostly shared by scholars, although disputed by others. Italian critics are almost unanimous in attributing the frescoes to Giotto while accepting that they were produced with considerable help from his assistants. The date of the cycle also cannot be verified, although it is generally agreed that it must have been executed between 1291 and 1294. The scenes are arranged according to a widely copied system, which is based on groups of three: each bay houses three scenes, each set into a square area separated by fluted columns that support a panelled frame above which stone consoles are painted. These are perspectively inclined so as to converge towards the central console, which thus appears to be the only truly frontal one, suggesting that the best vantage point for the observer to view the scenes is from the center of the bay.

■ Giotto?, *Death and Ascension of St Francis, Apparition to Fra Agostino, Verification of the Stigmata,* Upper Church, Assisi. The three-part scheme adopted by Giotto has the scenes grouped according to common themes. The stories reproduced in this group are the last ones in the cycle and describe the saint's death and his analogy with Christ, made explicit by the stigmata.

■ Giotto's assistants (Master of the Montefalco Crucifix?), *Liberation of Peter the Heretic,* Upper Church, Assisi. The tower of the prison is decorated with a continuous frieze along the model of the Trajan Column in Rome, which also echoes the fluted columns separating the scenes.

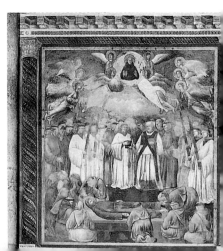

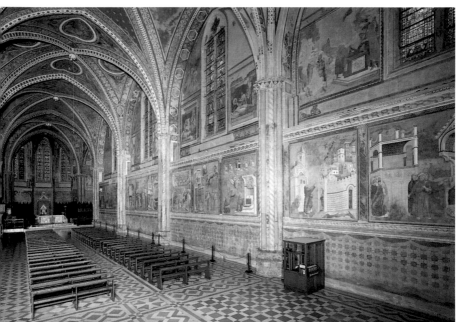

■ The lower part of each wall, below the dado, is covered by trompe l'oeil curtains and decorated with geometric patterns that echo the drapery design used in a number of the scenes. Giotto's eye for decoration goes hand in hand with his detailed observation of many aspects of everyday life.

■ The picture below shows the compositional structure of each bay: at the bottom is the area of painted drapery, in the middle tier the St Francis scenes, and in the upper tier the *Scenes from the Old and New Testament*.

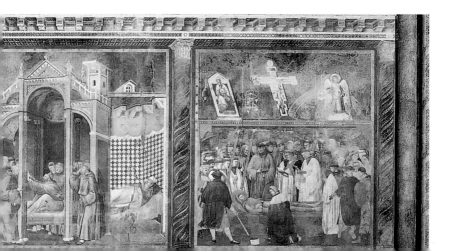

Renunciation of Worldly Goods

This scene, set in Assisi, shows St Francis, having removed all his clothing, rejecting the life his wealthy father, Bernardone, could have offered him. Instead he embraces poverty and acknowledges God alone as his father.

■ This detail shows the father being restrained from striking Francis with his hand by someone behind him. This introduces a subtle psychological note, which is emphasized by Bernardone's expression. Giotto stresses the contrast between the path Francis has chosen in full awareness and determination and his father's refusal to understand or accept it. Bernardone reacts angrily, as any parent might when confronted with their child rebelling against parental authority.

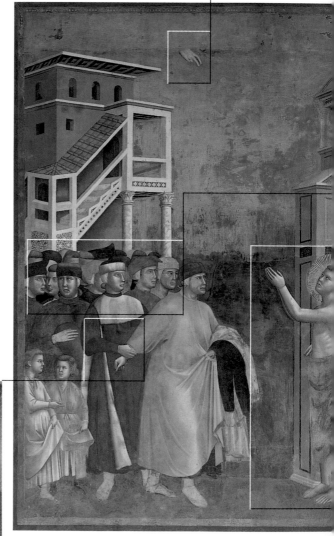

■ The hand of Almighty God, to which Francis' prayer is addressed, appears high above the clouds in a gesture of blessing. God was to have been shown in His entirety in the center of the scene, but only His hand is featured as a symbol of Francis' vocation. The symbolism is echoed by an imaginary line that connects the two hands, drawing the two parts of the scene together into a whole.

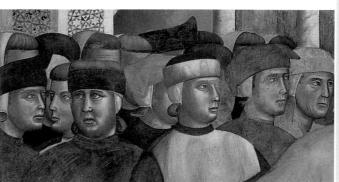

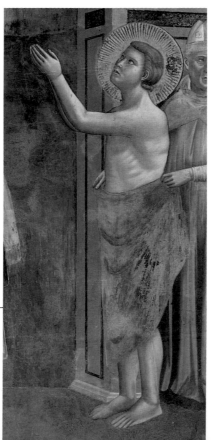

■ The scene is organized into two separate sections, with two groups of figures arranged in relation to their architectural background: the bishop and some followers are behind Francis while behind his father stand the people of Assisi, wearing traditional hats, and witnessing the whole event.

■ St Francis, drawn with anatomical precision, is the only figure to be shown naked, in contrast to the other, amply dressed figures. The saint looks upward in an absent expression which, through his direct dialogue with God, shows that he is almost unaware of what is going on around him.

Space divided into perspectival sections

T he innovative quality of the *Scenes from the Life of St Francis* at Assisi lies most of all in the lifelike sense of space in which the action and characters are set. Unlike the Renaissance concept of perspective, Giotto's treatment of space produces a theatrical effect that was totally new for its time, in which barely sketched movements and gestures interrelate in such a way as to animate our view of the whole, giving the impression that buildings, mountains, trees, and other features act as crucial elements around which the entire balance of the composition revolves and does not simply build up a perfunctory background. The scenes are thus made up of different areas, each with its own perspectival logic and set not against a gold or flat background but within a measured and very lifelike space, enabling us to interpret them in both a human and a religious context. This is further emphasized by the portrayal of St Francis as an ordinary man among other men, a man who lived around real buildings and real objects, a man whose very ordinariness was derived from his wish to carry out God's will. This is the key to the simple saintliness of Francis and indeed also to Giotto's innovative humanism.

■ The *Confirmation of the Rule* is set in an internal space which is structured not according to intuition but to a proper, scientific use of perspective, which adheres to the classical rules.

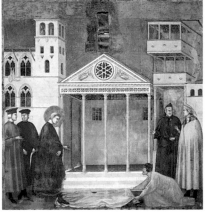

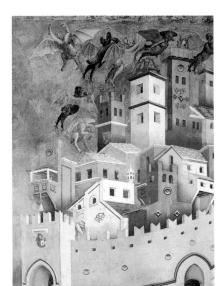

■ In *Exorcism of the Demons from Arezzo* Giotto shows the city as it was in his day: blocks of houses and towers forming an interconnected series of volumes and shapes.

■ The composition of *Homage of a Simple Man* (above) has an empty area in the center, creating a sense of space with its classical symmetry.

■ *St Francis Preaching before Honorius III* also shows Giotto's skill in building up perspective according to classical rules.

■ The dilapidated church in *Miracle of the Crucifix* reveals the close connection between the figure and the environment in which the scene takes place. The effect is a symbolic and also human exaltation of the saint.

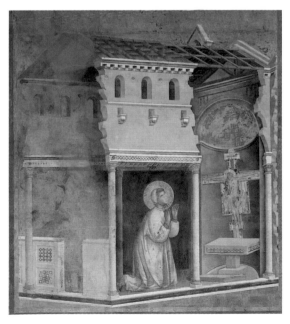

■ Arnolfo di Cambio, ciborium, Santa Cecilia in Trastevere, Rome. In the Assisi frescoes, Giotto seems increasingly to acknowledge Arnolfo as a true master in his perception of a wide-ranging, classical sense of space.

The Institution of the Crib at Greccio

A miracle occurred in the crib set up by St Francis in the castle at Greccio: the infant placed in the manger was identified as Jesus. This scene is famous for its treatment of space.

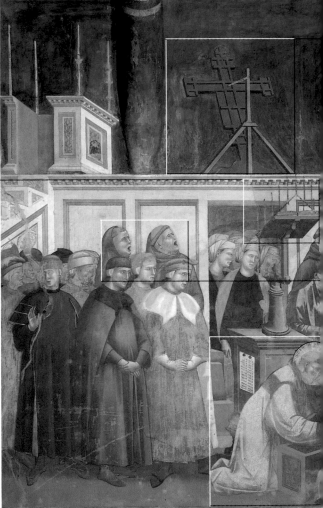

■ The scene takes place behind the enclosure which separates the presbytery from the nave and is taken up by the ciborium, which is derived from Arnolfo di Cambio, and by the foreshortened, candle-studded lectern on which rests the open missal. Giotto's rendering of the various sections is meticulous and his interest for real objects, no matter how simple, is once again in evidence.

■ The foreshortened cross, which hints at the space of the nave, is well known. Giotto meticulously reproduces it, taking care to convey the feel of the woodwork.

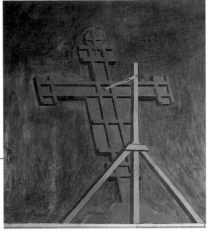

■ On the left are the steps leading up to the pulpit. Within this square area is a lively, animated group of friars and lay brothers. Each is characterized by distinct facial features and expressions, shown either singing or watching the scene intently.

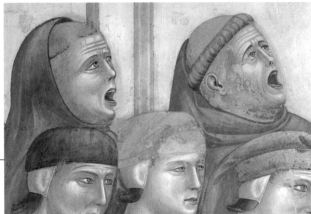

■ Giotto's painstaking rendering of reality can also be seen in this detail: the delicate fabric of the vestments, the geometric patterns of the altar cloth, the lettering on the sheet of paper fixed to the lectern, the manger's relief work which is derived from late antiquity. Note the light reflecting on the figures of the saint and the Child.

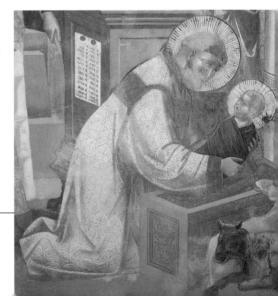

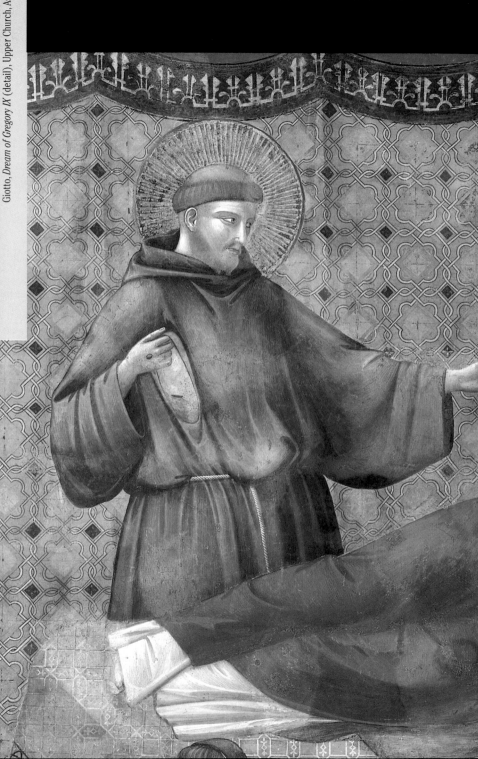

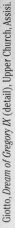

Giotto, *Dream of Gregory IX* (detail), Upper Church, Assisi.

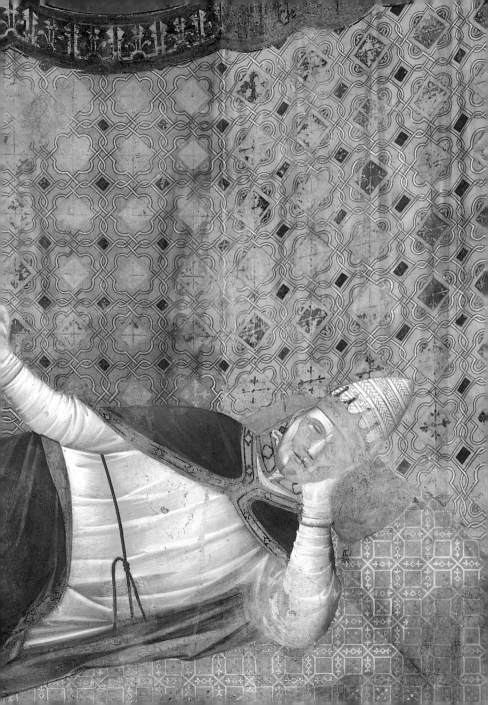

The question of the workshop

In any complete analysis of Giotto's activity the question of attribution invariably arises, and much scholarly attention has focused on distinguishing the master's own hand from that of the assistants who worked with him constantly from the time of the Assisi frescoes. The matter is particularly relevant when it comes to the final episodes of the St Francis cycle, where a change of style, evidenced by unusually crowded scenes and a certain decline in expression, can be noted – so much so as to suggest that these scenes might have been executed after Giotto's departure for Rome, presumably in 1297. Scholars have suggested the Santa Cecilia Master or the Master of the Montefalco Crucifix as the artists of some of these scenes. Giotto's so-called workshop was, from the master's youngest years, ample and diversified, and may be identified even in parts of some scenes that can be attributed to him with certainty, as in the group of women in the *Institution of the Crib at Greccio*, or in the faces of the soldiers and bishops in *St Francis Before the Sultan (Trial by Fire)*. It is generally agreed, however, that Giotto was responsible for the overall structure of each scene, so ensuring the coherent unity of the cycle.

■ Giotto?, *Stigmatization of St Francis*, Musée du Louvre, Paris. Despite the work's evident quality, a certain rigidity of outline, particularly in the saint's face, casts doubt as to who painted this scene. The panel bears the legend "OPUS JOCTI FLORENTINI".

■ Giotto?, *Madonna and Child*, Ashmolean Museum, Oxford. Painted just before the Padua frescoes, this small panel has been attributed to a number of artists: Berenson placed it within Giotto's circle, while Italian critics Previtali and Brandi attribute it to Giotto himself and the workshop respectively.

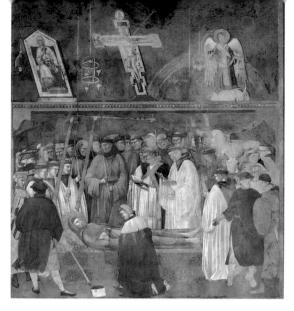

■ *Verification of the Stigmata,* Upper Church, Assisi. Part of a final group of three scenes, whose attribution to Giotto is excluded by almost all scholars. Their argument is based on the style, which is different from the other scenes.

■ This detail of the boy climbing the tree recurs in the frescoes of Padua.

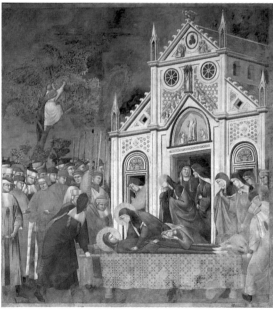

■ *St Francis Mourned by St Clare*, Upper Church, Assisi. The artist responsible for this scene may also have painted *Death and Ascension of St Francis.* Both are heavily crowded with figures.

■ *Entry into Jerusalem* (detail), Arena Chapel, Padua. The boy, similar to the one in the Assisi fresco above, reveals how the same iconographic elements could be used in more than one work.

Madonna and Child

Attributed almost unanimously to Giotto and chronologically very close to the Assisi frescoes, this work, now in the Uffizi in Florence, is "naturalistic" in its proportions and elegant in the execution of detail.

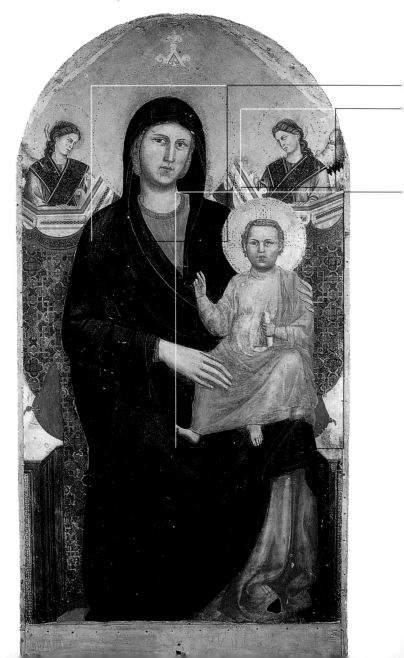

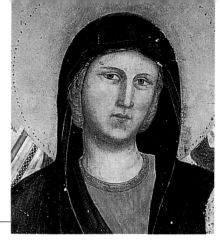

■ The Madonna's head, which is slightly inclined, is covered in a blue mantle, now nearly black, through which we can glimpse the red of her clothing. The position of her head enlivens her monumental, slightly fixed pose.

■ The angels on each side of the Madonna reveal an intricately decorated geometric pattern on their garments. Damage to the panel has resulted in the spatial depth of these figures being lost. Red is the dominant color, and is echoed in the drapery behind the throne.

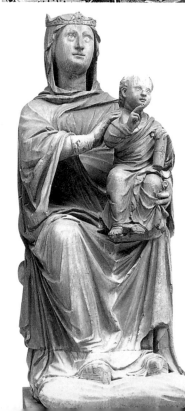

■ The Child, seated on the Madonna's knee, is shown from the front. His pose, although somewhat rigid, is well articulated, while the three-dimensional aspect of his body is emphasized by the bright red of the mantle, which stands out against the grey clothing.

■ Arnolfo di Cambio, *Madonna Enthroned*, Museo dell'Opera del Duomo, Florence. Giotto's work reveals a number of affinities with this Madonna, executed around 1295, in its monumental structure, pose, and some of the smaller details.

Early fourteenth-century Tuscany

The first half of the fourteenth century in Tuscany, and particularly in Florence, witnessed the continuation of the process of modernization begun during the previous century, which had led to the establishment of an active, entrepreneurial, and thriving society. Power in Florence lay in the hands of those families which controlled the most economically important guilds. They favored the building of splendid edifices, symbols of a modern mentality inspired by the principle of self-determination. The Palazzo Vecchio, the city's town hall, was built in the space of just a few years. Its interior was decorated with fresco cycles of a civic nature (such as conquered cities and the celebration of the illustrious Florentines), although these have not survived. Siena, too, enjoyed a period of success at this time, which fostered the development of a different kind of artistic culture, more aristocratic and imaginative thanks to the city's contacts with cultures from north of the Alps, the Ghibellines, and Giovanni Pisano.

■ The Palazzo Vecchio in Florence was built by Arnolfo di Cambio between 1299 and 1314, on land appropriated from the Ghibelline Uberti family. Conceived as a massive, rusticated fortified structure, it is softened by rows of mullioned windows and a tower situated off-center.

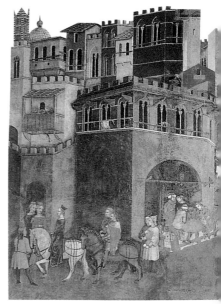

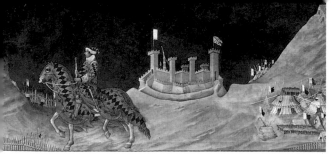

■ Simone Martini, *Guidoriccio da Fogliano*, 1330, Palazzo Pubblico, Siena. The conquering leader is shown with no attempt at realistic representation but rather as a metaphor for power as a whole.

■ This anonymous fresco in the Loggia del Bigallo in Florence shows a fourteenth-century view of the city, surrounded by its circular wall.

■ Ambrogio Lorenzetti, *The Effects of Good and Bad Government in the Town*, 1338, Palazzo Pubblico, Siena. Inspired by Aristotle and St Thomas Aquinas, these frescoes illustrate the principles of Sienese politics, celebrating the effects of a prosperous life in the city.

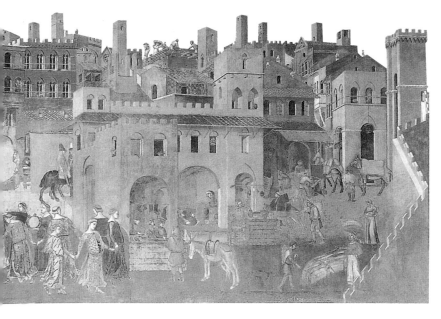

Rome during the Jubilee

Giotto made a second journey to Rome at the end of the thirteenth century. This was unquestionably a very stimulating and positive visit, judging from the effects it clearly had on Giotto's subsequent artistic output. The city boasted an urban landscape and an artistic culture that had evolved since the previous decade: the building and decoration of the Lateran and Santa Maria Maggiore was finished, and Pietro Cavallini had completed his work on Santa Maria and Santa Cecilia in Trastevere, achieving delicate, luminous color effects of which Giotto would certainly have been aware. Arnolfo di Cambio had created more classical and balanced proportions in the ciborium of Santa Cecilia in 1293, which would influence the spatial quality of the Padua frescoes. The date of Giotto's Roman visit is uncertain. Recent studies have disproved the theory that his journey coincided with the Jubilee of 1300, suggesting instead that it could have taken place in 1297. This was the year in which the loggia, now demolished, was built by order of Boniface VIII to house a fresco (*Boniface VIII Proclaiming the Jubilee*) that aimed to ratify the Pope's highly controversial election. This work, which survives only as a fragment, is unanimously attributed to Giotto. Restored in 1952, it enables us to appreciate its measured classical structure and vivid coloration; the papal commission confirmed the high regard in which Giotto was held.

■ Giotto, *Boniface VIII Proclaiming the Jubilee*, San Giovanni in Laterano, Rome. This is all that survives of the fresco, a clearer picture of which can be derived from a sixteenth-century watercolor drawing in the Biblioteca Ambrosiana, Milan. The treatment may be likened to certain triumphal Roman monuments.

■ Arnolfo di Cambio, *Monument to Boniface VIII*, c.1300, Museo dell'Opera del Duomo, Florence. This monument marks a return to sculptural portraiture of the classical manner.

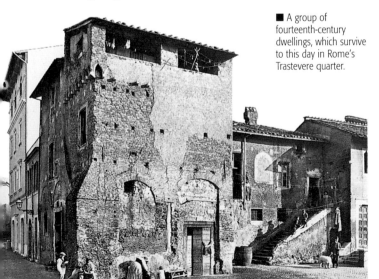

■ A group of fourteenth-century dwellings, which survive to this day in Rome's Trastevere quarter.

■ Benedetto Bonfigli, *Boniface VIII Conferring the Rule of the Franciscan Order on St Ludovic of Anjou*, 1454, Palazzo dei Priori, Perugia.

■ Map of Rome drawn by Paolino da Venezia, dating from the early fourteenth century. The city is shown enclosed within its circle of walls and intersected by the Tiber river. The hills are also shown, together with the densely crowded buildings.

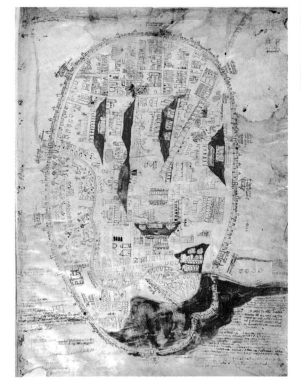

59

Badia Polyptych

Dating from around 1301, the polyptych, originally in the Florentine Badia church and now in the Uffizi, is almost unanimously attributed to Giotto and contributes to our understanding of the period he spent in Florence before his departure for Padua.

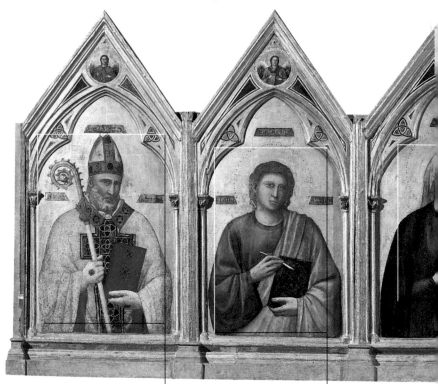

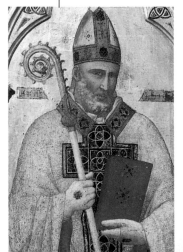

■ *St Nicholas* appears to be solidly constructed, the figure gently inclined to suggest depth within the gold background. The saint's figure is, however, more elongated than the others, revealing a lesser characterization and perhaps a more minor formal synthesis. The details are meticulously rendered.

■ The polyptych is of great interest even in such a small frame, which is similar to the treatment adopted by Giovanni Pisano in the pulpit at Pistoia (a curved arch inside a pointed arch). Within the pointed arches are tondos showing *Four Angels* and, in the central tondo, *Christ Giving His Blessing* (left), all characterized by vivid colors.

■ The figure of *St John the Evangelist* (left} has been likened to the Padua figures for the stylistic skill with which it has been executed. This section reveals a perfect balance between volume and spatial depth. The contrasting colors of the garments are softened by the light that comes from a source somewhere to the left.

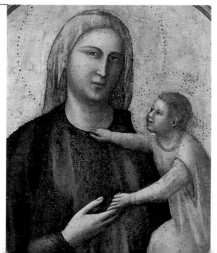

■ In the *Madonna* Giotto seems to smooth out any residual rigidity, arriving at a new iconography which is charged with humanity. The features and overall outline of the face are rendered by means of chiaroscuro. The Madonna turns slightly towards the Child in a gesture of tenderness. These elements herald the Paduan frescoes.

Giotto in Rimini

Evidence that Giotto was present in Rimini was confirmed by Riccobaldo Ferrarese in 1312 when he referred to the artist working in the church of San Francesco. When Sigismondo Malatesta transformed the original church into the so-called Tempio Malatestiano, however, all trace of Giotto's work was lost with the exception of a magnificent *Crucifix*, which critics now agree is by Giotto's own hand. The work has been damaged and is in a precarious state of repair but nevertheless reveals the high quality of Giotto's artistry, which was also noted by local artists. An analysis of the Rimini *Crucifix* shows it to be more elongated in shape and more closely fixed to the wooden support than the one in Santa Maria Novella. The rendering of the limbs is also executed with a greater subtlety and elegance. The figure's outline is clearly worked, emphasizing anatomical details and enabling the figure to stand out against the background of precious fabric, sophisticated colors and skilfully used shadows. There is still debate over the chronology of Giotto's trip to Rimini: according to some sources, it took place after his visit to Padua but other sources point to the rendering of the loincloth, which harks back to the legacy of Cimabue and thus appears to suggest that the work dates from a time before the Padua cycle.

■ The interior of the Tempio Malatestiano today. Sigismondo Malatesta commissioned Leon Battista Alberti to transform the church into a monument celebrating his family.

■ Giovanni da Rimini, *Crucifix*, 1309, San Francesco, Mercatello. One of the first artists to follow Giotto's example, he contributed to the definition of a Rimini School.

■ Giotto, *Crucifix*, Tempio Malatestiano, Rimini. The side sections, probably multifoiled, are missing, the figures enclosed within octagonal panels.

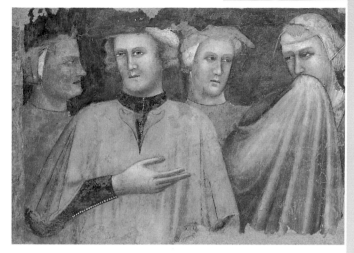

■ Francesco da Rimini, *Four Onlookers* (detail, above), c.1320, Pinacoteca Nazionale, Bologna. Little is known about this artist, making it difficult to reconstruct his work. Nevertheless, frescoes in the Franciscan refectory in Bologna which are attributed to him were inspired by Giotto's work.

■ Pietro da Rimini, *Marriage at Cana* (detail, below), Chapel of San Nicola, Tolentino. Rimini, one of the most representative artists of the so-called Rimini School, blended Giotto's influence with the Paduan tendency toward immediate, lifelike representations.

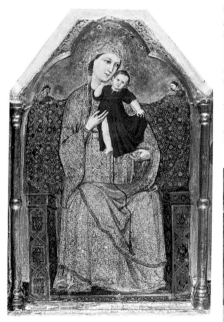

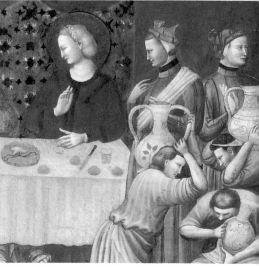

■ Arengo Master, *Madonna and Saints Triptych* (detail), fourteenth century, Museo Correr, Venice. The physiognomy in the Rimini School owed much to Giotto's art in its more modern conception of figures, which are viewed as spatial entities. It also revealed its own individual traits with more relaxed poses and a Gothic feel.

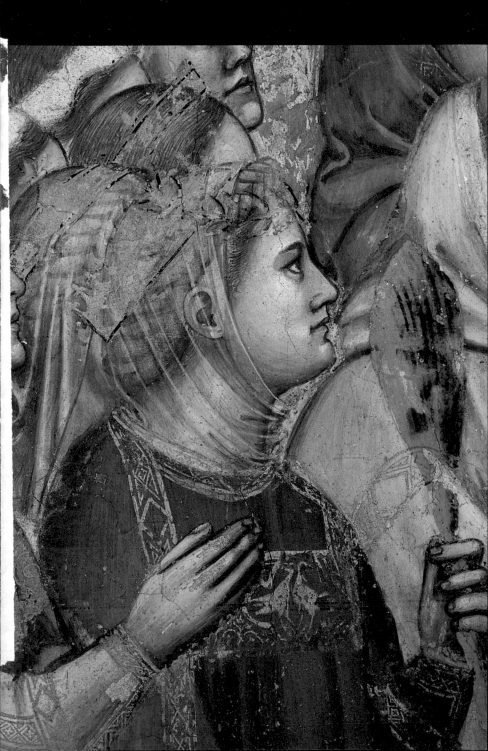

The master in Padua

After his journeys to Assisi, Rome, Florence, and Rimini, Giotto finally arrived in Padua, a city which houses the highest and most consummate evidence of his artistic activity. We assume that it was in 1302 that Giotto was called on once again by the friars to glorify their founder in the order's second church, dedicated to St Anthony. This is recorded in many different historical sources, including Ghiberti, Michele Savonarola, and Giorgio Vasari who, up to the second half of the seventh century, were able to admire the frescoes in the basilica of St Anthony. After this time all trace of them was lost and it was only in the nineteenth century that some fragments were found in the Sala Capitolare of the convent, which appeared to be by Giotto. Also lost are the frescoes in the Palazzo Comunale, now known as the Palazzo Ragione. The frescoes in the Arena Chapel have survived in perfect condition, however, and constitute one of the most significant chapters in the history of Italian art. In them Giotto's synthesis between figures and space and his conception of them as a single coherent unit is taken to its highest level, corresponding to an early humanist vision according to which man is placed at the very center of his history, fully aware of his human individuality.

■ The basilica of St Anthony in Padua was built from 1232. Its monumentality reveals the input of different cultures: Romanesque façade, Gothic pointed arches, and Oriental hemispheric domes.

■ Giotto's presence in Padua also influenced illuminations produced in the fourteenth century.

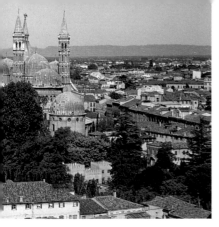

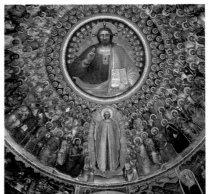

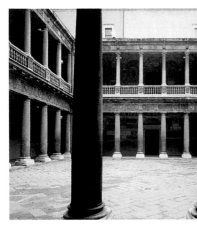

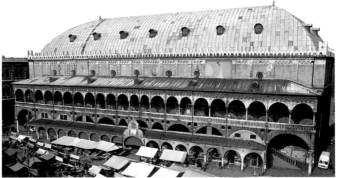

■ Giusto de' Menabuoi, *Pantocrator* (detail), Baptistry Vault, Padua. The commissioning of de' Menabuoi for this important work reveals the spirit of artistic initiative that was prevalent in fourteenth-century Padua.

■ This view of Padua shows the central position of the majestic basilica of St Anthony within the city. The five domes, Oriental in feel, recall St Mark's Basilica in Venice and bear witness to the close relationship between the two cities.

■ The forecourt of Padua University. Founded in 1222, this is one of the oldest universities in Europe and has graced the city with a spirit of research and a lively cultural life over the centuries.

■ Padua's Palazzo della Ragione is one of the largest medieval buildings in Europe. Built in the 1220s to house shops, offices, and a court of law, it was subsequently remodelled. Covered by a roof in the shape of an upturned ship's keel, its long sides reveal a three-layered portico.

The golden age of Padua

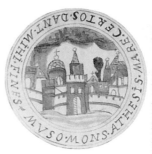

The period between the second half of the thirteenth century and the first decade of the fourteenth is regarded as a kind of golden age in historical writings about Padua. In 1256 a crusading army of Guelph exiles and partisans from neighboring cities had conquered the city, putting an end to the tyrannical rule of Ezzelino da Romano, which dated back to 1237. In the years following this conquest Padua benefited from stability and freedom, guaranteed by the restoration of its constitution. Padua extended its control over a much wider territory, stretching as far as neighboring Vicenza and, later, Rovigo. The advantages of this altered political order were shared between the city's most powerful families, citizens who were members of the guilds, and professionals. These people, particularly the Scrovegni, Carraresi, and Capodivacca families made up an emerging new class, which was wealthy, enterprising, and able to promote cultural initiatives at the highest level. Works such as the rebuilding of the Palazzo Comunale and the Basilica of St Anthony were commissioned and artists of Giotto's calibre were called upon to decorate parts of the city.

■ The seal of the city of Padua. Its iconography shows the city as Giotto would probably have known it. The inscription makes a proud reference to the city's boundaries.

■ Idealized reconstruction of the chariot of the city of Padua. Biblioteca del Museo Civico, Padua.

■ The opening lines of the first book of Padua's statute, dating from the second half of the thirteenth century. Padua was governed by a Grand Council, which from 1277 was made up of a thousand members out of an adult male population of about 11,000 inhabitants. So large a representation in the city's government enabled a more direct and immediate expression of the city's interests.

■ Giusto de'Menabuoi, *Fresco with St Anthony and the Blessed Luca Belludi*, c.1382, Basilica of St Anthony, Padua. The subject places this work directly in the context of Padua's history: St Anthony reveals to the blessed Luca Belludi, to whom the chapel with the fresco is dedicated, that Padua has been liberated from the tyranny of Ezzelino.

■ Montagnana, Tower of Ezzelino, thirteenth century (left). Ezzelino III da Romano, lord of Verona, Vicenza, and Padua, inherited the Treviso fiefs and, with the support of Frederick II, built up a large signory for himself between the Brenta and Adige valleys, on the route between Germany and Italy. His savage and immoral behavior was legendary and led to his excommunication in 1254.

■ Coins from the Paduan mint, thirteenth century. After Ezzelino was deposed, Padua began to mint proper money, placing a characteristic star in the center of its coins. This shows how the monetary system which had been in place until then, based on the integrated currencies of Verona and Venice, was in crisis and further emphasized the renewed economic vitality of the city.

A usurious banker

SCROVEGNI

The Arena Chapel was commissioned by Enrico Scrovegni, son of the infamous Reginaldo, the usurer who is mentioned by Dante in Canto XVII of the *Inferno*. On February 6, 1300, Enrico purchased a large plot of land within the Roman Arena in Padua, on which stood a small church dedicated to the Virgin. He arranged for a large palace to be built there and wanted the church, now known as the Arena or Scrovegni Chapel, to be rebuilt next to it in a structure which survives to this day. Work on the chapel proceeded apace, if we can trust the date in which it began as being 1302, and, according to scholars, once the decoration of the wall was complete, the chapel was consecrated in 1305. It consists of a single nave with a large rounded vault above, with a presbytery covered by a Gothic transept with vaulting ribs, which houses the tomb of Enrico Scrovegni and his wife. The presbytery is said to have been built between 1317 and 1320. It is possible that Giotto may have been responsible for the entire design of the chapel.

■ The seal of the Scrovegni family. The Scrovegnis enjoyed a very prestigious position in Padua during the period after Ezzelino was overthrown. Together with other families, they were involved in the government of the city, securing prosperity for their social rank.

■ Giovanni Pisano, *Madonna and Child* c.1305, Arena Chapel, Padua. The Madonna is placed before the Scrovegni sarcophagus, pointing to the modernity of the banker's commission, even in terms of sculpture.

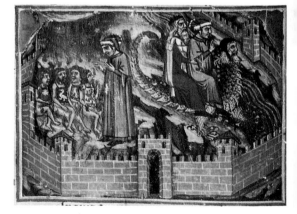

■ The interior of the Chapel, viewed from the entrance, showing the triumphal arch which leads into the presbytery, with the tombs of the Scrovegnis. Painted on the arch is the Almighty charging the Archangel Gabriel with the Annunciation to Mary.

■ Giotto, *Last Judgment* (detail), Arena Chapel, Padua. The detail shows Enrico Scrovegni offering a model of the chapel to Mary, who is accompanied by a saint and an angel, with which he is seeking expiation for his father's sin of usury.

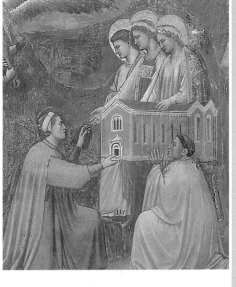

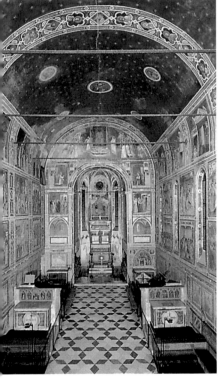

■ *Dante Speaking to the Ghosts of the Usurers*, Biblioteca Angelica, Rome. This miniature is taken from a Tuscan manuscript of the *Divine Comedy* dating from the late fourteenth century showing Dante's punishment of usurers on flaming sands.

■ A closer view of the interior of the chapel showing Giotto's magnificent *Last Judgment*. The interior is extremely precious because of its elaborate decoration and is in sharp contrast to the exterior.

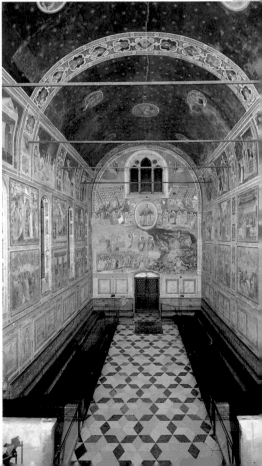

Last Judgment

This work on the entrance wall of the Arena Chapel is traditional in its iconography and grandiose in structure. It can be dated at the end of the cycle and is believed for the most part to be the work of Giotto's pupils.

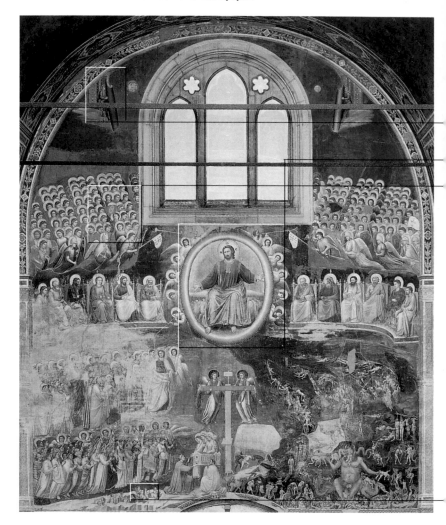

■ On the upper wall on each side of the large three-mullioned window two angels are depicted unrolling the great book of the universe with the sun and the moon. The semicircular volume is an interesting solution to a spatial problem, producing an effect of circular depth: a sign of Giotto's modern conception of space.

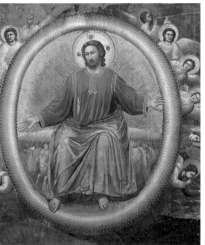

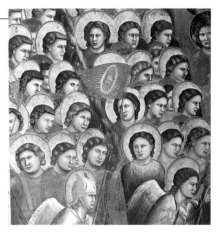

■ The rows of angels, together with the Fathers of the church and Christ, constitute the church triumphant. The arrangement of these figures in separate blocks and rows of three echoes the curved shape of the Fathers' thrones.

■ In the middle of the fresco is a majestic image of *Christ in Judgment*. His body is represented as substantial and powerful, his arms encompassing the remaining space. His features are similar to those in the *Resurrection*.

■ The resurrection of the dead, below left, is expressed in explicitly realistic terms, with grotesque notes reminiscent of the *Last Judgment* in the Baptistry in Florence. The rock out of which the bodies emerge reveals the same craggy features seen in the rocky landscapes of the Assisi cycle.

The decorative structure of the Arena Chapel

The frescoes in the Arena Chapel constitute an extraordinary decorative display. Each episode appears to be enclosed within the space reserved for it without sacrificing the unity of the composition, which is closely connected with the real space provided by the surrounding architecture. As in the St Francis cycle, these scenes are arranged in three tiers above a high dado which substitutes marble-effect inlay for the painted drapery effect found at Assisi, interspersed with the monochrome allegorical figures of the *Vices* and *Virtues*, characterized by Latin inscriptions, which may have been executed at a late stage in the decoration. Each scene is framed by decorative borders (mostly the work of assistants), which are interesting both for their ornamental quality and for what they tell us about Giotto's interest in miniature painting. Within these bands are medallions of different shapes, showing episodes from the Old Testament that refer to the scenes they frame, or heads of saints arranged according to a precise hierarchy. The link between the figures in the ornamental framework and those in the main scenes shows how the entire cycle is the result of a complex iconographic scheme which is a summary of the biblical and Christian tradition. The decorative features and the symbolism of the work are completed by the large vault, which is divided into two sections. Against the star-studded lapis-lazuli blue background are two tondos in which *Christ the Redeemer* and the *Madonna and Child* are depicted against a gold background, surrounded by images of the *Prophets*.

■ Giotto, *Crucifix*, Musei Civici, Padua. This crucifix is from the Arena Chapel and is attributed to Giotto, with clear evidence of the intervention of assistants.

■ The allegorical figure of *Envy* is executed according to a new iconography: a serpent emerges from the figure's mouth, referring to the poison within an envious person.

■ Set in smaller tondos around the *Madonna* in the vault are the figures of *Isaiah, Malachi, Daniel*, and *Baruch* (left). This is a cosmic vision dominated by the centrality of the Virgin.

■ Giotto, *Injustice*, Arena Chapel, Padua. This is the most complex of the allegorical figures: the old man, seated among the ruins of a castle, appears to be a magistrate apportioning justice in his favor.

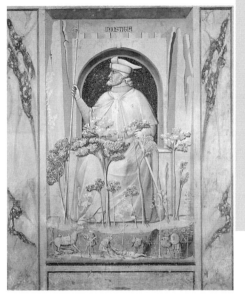

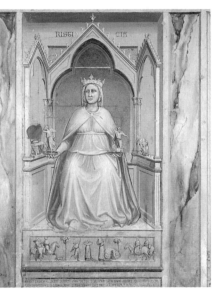

■ Giotto, *Justice*, Arena Chapel, Padua. This allegorical figure reveals the same structure and volumes as *Injustice*, and is perfectly balanced within the architectural setting in which it is placed. Classical and early Christian elements may be discerned, together with a Gothic tendency reminiscent of Giovanni Pisano's work.

■ The ornamental framework reveals a wealth of patterns and a vivid range of colors which contributed further to the unity of the cycle as a whole. These bands may have been executed by Giotto's workshop or by assistants hired *in situ*. The overall design of the chapel, and certainly its decoration, is the work of Giotto.

1302–1305

Annunciation to St Anne

St Anne, the Virgin's mother, receives the Annunciation of Christ's incarnation in her house, a square, almost cubic block. The news is borne by an angel who appears at a window. Outside, a handmaiden sits spinning.

■ The handmaiden is solidly represented, seated in a pose that defines the space around her, a small exterior porch surmounted by a balcony. The folds of her clothing suggest the outline of her body and the depth of the angle between the trunk and the knees. The close link between figures and space, already seen in the Assisi frescoes, is further developed here.

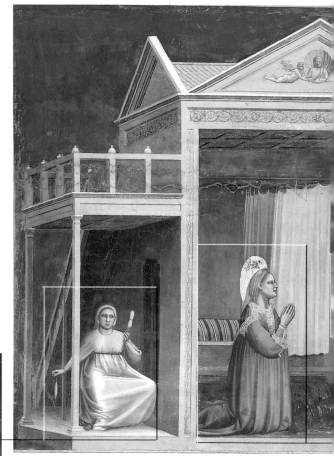

■ In the sparsely furnished room, women's working artifacts are shown on the wall and on the ledge, giving us some clue as to St Anne's lifestyle. Such inclusions are statements of Giotto's interest in small everyday objects, which he has depicted in minute detail.

■ Giotto opts for an unusual solution in his positioning of the angel, showing him peering through the window having flown down from on high. A crack that cuts horizontally through the angel's head runs right across the entire scene.

■ Like all the other figures in the cycle, St Anne, shown kneeling in the middle of the room, reveals a clearly defined physical outline, the three-dimensionality of her body heightened by the use of chiaroscuro. The color of her gown contrasts with the green background of the room. The face, like all the others, is rendered with very delicate brushstrokes.

■ The Annunciation to Mary is painted on the chapel's triumphal arch, below the representation of Paradise. Two aedicules show the Archangel Gabriel and Mary (below), a central figure in the salvation of humanity by God's will.

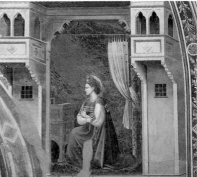

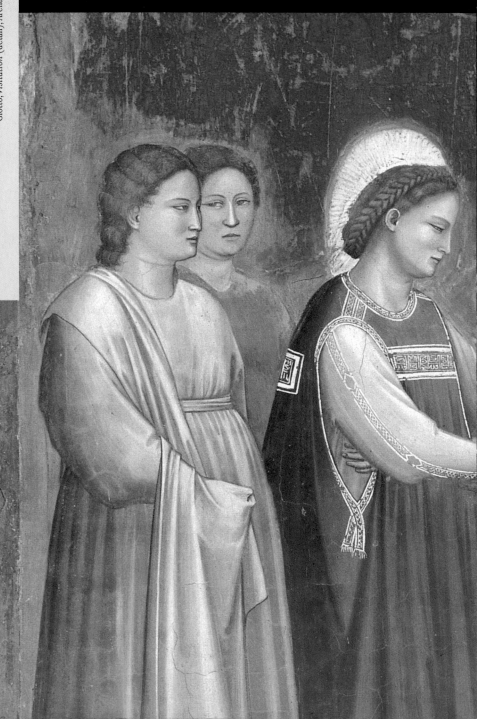

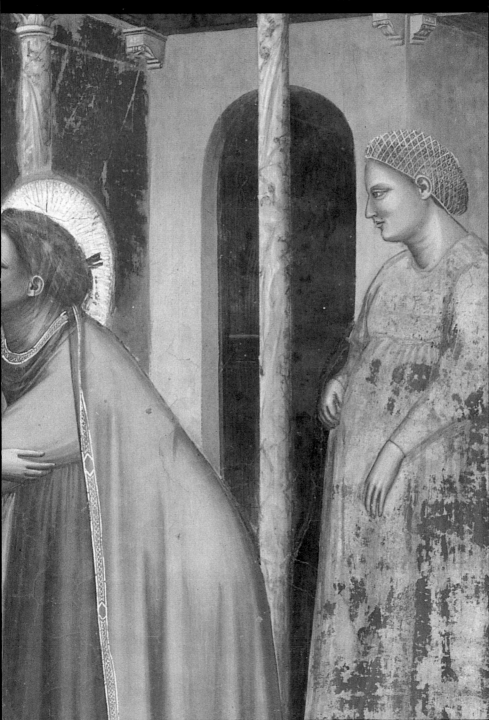

Plan of the scenes in the Arena Chapel

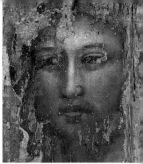

The murals in the Arena Chapel are divided into three tiers. The cycle begins in the upper tier of the right-hand wall, close to the triumphal arch, with the *Scenes from the Life of Joachim* and continues on the opposite wall with *Scenes from the Life of the Virgin*, culminating in the *Annunciation* on the triumphal arch itself where the section leading up to the birth of Christ ends with the *Visitation*. The *Scenes from the Life of Christ* begin on the right-hand wall of the central tier, continue on the wall opposite, from the chapel entrance, and then in the lower tear to the right of the arch, finally ending on the left-hand wall of the entrance.

■ 1 *The Almighty* A and B *Tribunes*, 2 *Expulsion of Joachim from the Temple*, 3 *Joachim among the Shepherds*, 4 *Annunciation to St Anne*, 5 *Joachim's Sacrificial Offering*, 6 *Joachim's Dream*, 7 *The Meeting at the Golden Gate*, 8 *Birth of the Virgin*, 9 *Presentation of the Virgin in the Temple*, 10 *The Rods Brought to the Temple*, 11 *Prayer of the Suitors*, 12 *Marriage of the Virgin*, 13 *Wedding Procession*, 14 a and b *Annunciation*, 15 *Visitation*, 16 *Nativity* 17 *Adoration of the Magi*, 18 *Presentation in the Temple*, 19 *Flight into Egypt*, 20 *Massacre of the Innocents*, 21 *Christ among the Doctors*, 22 *Baptism of Christ*, 23 *Marriage at Cana*, 24 *Raising of Lazarus*, 25 *Entry into Jerusalem*, 26 *Expulsion of the Money-changers from the Temple*, 27 *Judas Receiving Payment for his Betrayal*, 28 *Last Supper*, 29 *Washing of Feet*, 30 *Kiss of Judas*, 31 *Christ Before Caiaphas*, 32 *The Flagellation* 33 *The Road to Calvary*, 34 *Crucifixion*, 35 *Lamentation*, 36 *Noli me tangere*, 37 *The Ascension*, 38 *Pentecost*, 39 *Last Judgment*, 40 a-g *Virtues*, 41 a-g *Vices*.

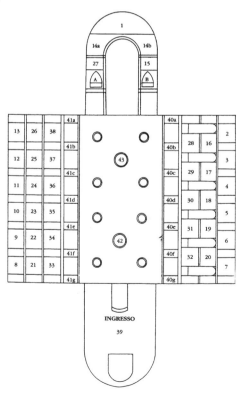

■ The figure of the Almighty at the center of the lunette in the triumphal arch is painted onto a panel inserted into the wall. The supreme skill with which the facial features have been painted, delicately shaded using chiaroscuro, make this unquestionably the work of Giotto.

■ *Massacre of the Innocents.* The narrative takes place against an urban background. Some identify the church on the right as the polygonal church of San Francesco in Bologna, although it also evokes echoes of the Baptistry in Florence. The scene is one of the liveliest in the entire cycle: Giotto chose to paint even the faces of the crowd of women with expressive characterization.

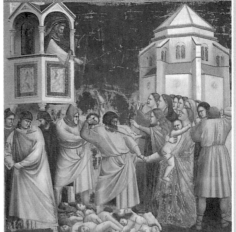

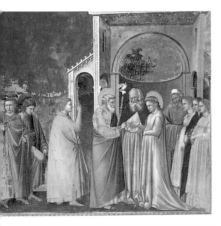

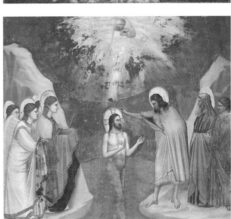

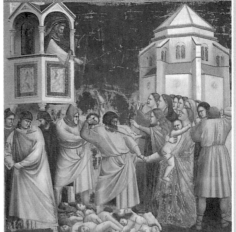

■ *Marriage of the Virgin.* The architecture in this scene is the same as in the other scenes, almost by way of a constant background to ensure continuity between the episodes.

■ *Entry into Jerusalem.* The figure hiding his head under the cloak of the person in front of him adds an amusing touch to this narrative.

■ *Baptism of Christ.* This scene marks the beginning of the episodes where Christ becomes the central figure. Set between two banks, the scene is traditional in its iconography and has been likened to the style of Pietro Cavallini, particularly in the figure of Jesus.

The narrative

The frescoes in the Arena Chapel once again unite elements from both the Old and the New Testament: the latter is evoked in the four-foiled panels in the ornamental bands. In Padua, too, the dominant aim was to narrate a great sacred poem, which begins with the portrayal of the *Almighty* and ends with the *Last Judgment*, the beginning and end of time. In terms of their iconography, the stories are inspired by two literary sources: the scenes involving the Virgin, St Anne, and Joachim are derived from the Apocrypha; those about Christ from the New Testament. What we have here, therefore, is sacred history, but rendered in a human, earthly context, which is emphasized by a draughtsmanship that deliberately rejects three-dimensionalism, in order to immerse itself in history both in terms of time and place. The narrative tone is solemn but enlivened by the different levels at work within each scene. The scenes can also be interpreted as evoking Giotto's time, with the depiction of many different aspects of everyday life – including the basest. In this sense Giotto adhered to the Gothic culture, a sign of his modernity.

■ *Expulsion of the Money-changers from the Temple.* This episode (below) shows Jesus' wrath as he condemns the trade being plied in the Temple. The narrative becomes inflamed with drama and focuses on Jesus' irate gestures.

■ *Birth of the Virgin* (detail). An everyday detail of the customs that prevailed in Giotto's time: a woman hands over clean linen after the birth of the infant.

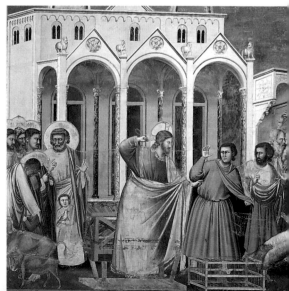

■ *Flight into Egypt*. The pivotal point in this the fourth scene in the life of Jesus is the central group of the Virgin and Child astride a donkey. This is echoed by the pyramid-shaped rock in the background, creating a spatially and visually perfect synthesis. Lingering over certain details such as footwear, or the straw of the basket, shows how Giotto focused both on the overall meaning of the scene as well as on its attendant elements. It was this attention to concrete objects that characterized Giotto's innovative approach.

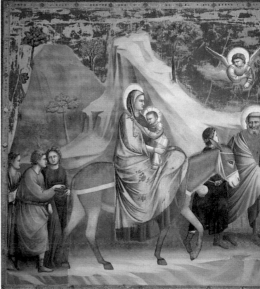

■ *Joachim Among the Shepherds*. Banished from the Temple because his marriage to Anne was childless, Joachim took refuge among shepherds (above). This scene creates an expressive unity between the human dimension, the rocky landscape, and the animals.

■ *Trial by Water*, frescoes on the apse of Santa Maria foris portas, Castelseprio. The episode, from the Apocrypha, shows the Virgin proving the conception of Jesus.

The Apocrypha

The Apocrypha (from the Greek *apokryfos*, hidden) is the name given to a group of 14 books not considered to be canonical, whose authorship, such as St James in the case of the *Scenes from the Life of Joachim*, *St Anne*, and *the Virgin*, is considered to be doubtful. In Catholic tradition, these books are included in Greek and Latin translations of the Bible as part of the Old Testament. The Protestant tradition, on the other hand, omits these books from the Old Testament section of the Bible.

1302–1305

The Meeting at the Golden Gate

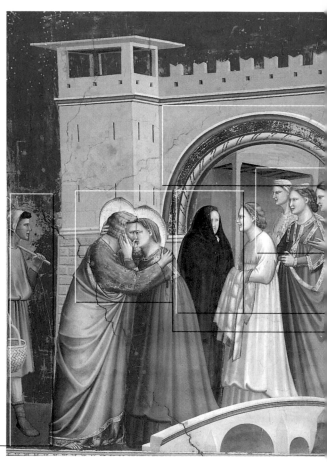

■ A young shepherd witnesses the meeting. Although he is only partially seen, his humble clothing is well-defined. He thus acts as a reminder of the previous episodes in which Joachim was depicted among the shepherds, who he had sought refuge with after being banished from the Temple. In the cycle in Padua the shepherds can be identified by certain attributes such as their shabby, thick, coarsely woven clothes without any adornments.

■ The curved arch of the door recalls the model of the Augustan Arch at Rimini. This reveals how Giotto was influenced by a classical concept of architecture and that he was probably familiar with such monuments.

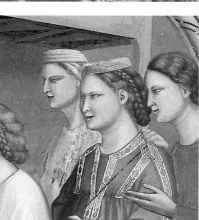

■ The clothes, headgear, and the manner in which the hair is styled in the group of women attending Anne is very sophisticated, and typical of Giotto's time.

■ Among the group of women witnessing the meeting between the aged couple, a female figure appears cloaked in black, whose presence has never been clearly interpreted. The color black creates a chromatic break in the harmony of the scene.

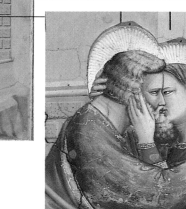

■ The old couple's embrace represents the focal point of the scene. Their bodies are defined in terms of volume, the folds of their clothing adding a sense of weight to the outlines of their sturdy, realistic forms. Even though they are partly concealed, Giotto has succeeded in conveying an intensely human and religious sense of conjugal tenderness in the faces of these two people.

A monumental concept of space

A constant element in the Padua frescoes, as with the Assisi frescoes that precede them, is the relationship between the figures and the space around them. It is in the Padua cycle that this synthesis finds its most supreme expression. There is a greater sense of space here, and Giotto introduces a novel touch with the repetition of architectural or landscape backdrops in order to unify episodes that follow one another chronologically. This gives the composition a measured sense of order. Giotto favors a simple treatment in his use of architectural elements: buildings are foreshortened in order to determine specific volumes, in respect of which the figures are placed slightly away from the middle axis. Aclassical language characterizes Giotto's representation of architecture, particularly in its proportions, which appear to be the same as those of the human figure. Backgrounds, and especially landscapes, are characterized by vast skies, their vivid blue color constituting a recurringnote. Landscapes are simple, with rocky, barren land on which small trees sprout and became increasingly more detailed.

■ *Expulsion of Joachim from the Temple*. The backdrop to this episode is reminiscent of the presbytery of Santa Maria in Cosmedin. The foreshortening enables the viewer to note the secondary scene in the enclosure.

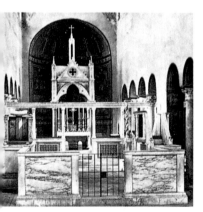

■ Santa Maria in Cosmedin, twelfth-thirteenth century, Rome. The presbyteries in early Christian basilicas are the model for some architectural elements in the *Scenes from the Life of Joachim* and *the Life of the Virgin*.

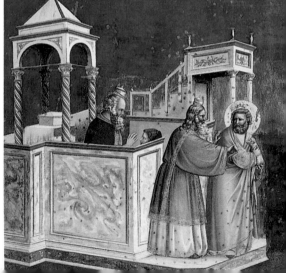

■ *Joachim's Sacrificial Offering.* This scene is set in the same kind of sharp, splintered, rocky landscape that is depicted in the Assisi frescoes. Joachim's bended pose is situated in parallel with the incline of the rock, while the vertical rock mass rising to the left emphasizes his outline as he prays.

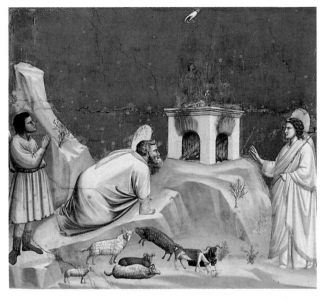

■ *Tribune.* Situated in the central part of the triumphal arch, this is a highly inventive device, which reveals Giotto's experimentation with the concept of space and his knowledge of perspective.

■ *Presentation of the Virgin in the Temple.* This scene revolves around the same architectural setting found in *Joachim's Expulsion from the Temple*, seen here from a different angle. Note how Giotto arranges the figures within the space so that the picture appears to be made up of a balanced, but highly lifelike combination of empty and crowded areas.

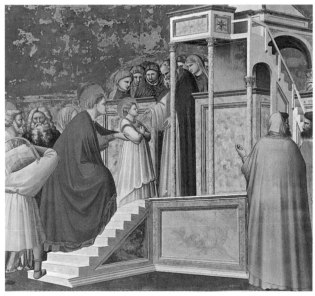

Adoration of the Magi

This solemn composition is set inside a hut. The scene and its surroundings are Gothic, and the way in which the different parts are structured is stylistically similar to the Pisa School.

■ The camel was a novel touch in the iconography of scenes depicting the Magi. Two are included here, positioned close together, the perspective between them emphasizing the depth of the reduced space.

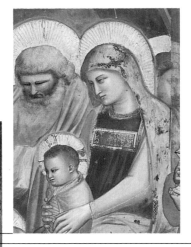

■ The Holy Family is gathered under the roof of the hut and is positioned slightly off center to make space for the kneeling king. Joseph and Mary are solemn in their acknowledgment of the Magi's tribute, their pose contributing to the courtly feel with which the scene is imbued.

■ The angel on the right stands erect, the outline of his body emphasized by the full-length drapery. At his feet we can see the intricate embroidery, worked in gold, around the hem, which underlines the courtly tone of this representation.

■ *Nativity* (detail). The continuity between this scene and the *Adoration of the Magi* which follows is in the repetition of the hut and Madonna's face. Note, however, the position of her veil and intense facial expression here.

■ The Magi introduce a series of several "courtly" figures that make up the retinue of the three kings in subsequent Magi scenes. Giotto suggests rank without pomp, stressing the solemnity of the figures and including some elegant details, such as the red footwear glimpsed through the cloak.

LIFE AND WORKS

The figures

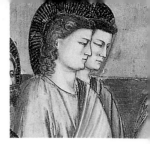

The innovative quality of the Padua frescoes is also evident in Giotto's concept and representation of the human figure in an architectural manner, each separate part fusing into a harmonious unity of proportions and a monumentality of form. In the Assisi cycle the figures often crowd the scenes, characterizing them dramatically, but in the Arena Chapel a calmer narrative prevails, in which the reduced number of attendant figures enables us to focus more clearly on the central protagonists of each scene. The main figures are still statuesque, influenced by Pisan sculpture so that they appear to be almost carved out of stone. They are softened by a combination of color and light, however, which brighten their clothing and make their faces translucent. Giotto portrays a real, tangible humanity, each figure having its own particular facial expression, characterized by psychological features. He distinguishes between different social ranks such as shepherds, handmaidens, priests, and soldiers by portraying different types of face, ranging from delicate to coarse, and by means of everyday elements such as clothing and other external attributes.

■ *Washing of Feet* (detail). The Apostles' faces make up a veritable portrait gallery, the variety going further than in the Assisi frescoes and displaying a range of ages. Each figure has his own hair color and style and the individual beards are all slightly different.

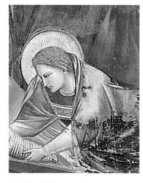

■ The delicacy and smoothness of Mary's face in the *Nativity* exemplify youth and female beauty.

■ *Presentation in the Temple* (detail). The biblical prophetess Hannah is shown as an old woman: her monumental body is slightly hunched, her face tired and lined, with wrinkles around her eyes and mouth.

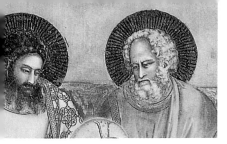

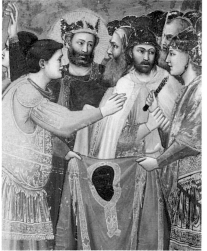

■ *Joachim's Dream* (detail, below). The sleeping Joachim appears to be sculpturally encased in a cloak that envelops him. The folds are drawn in a powerful, incisive way, while chiaroscuro gives this figure a supple smoothness.

■ *Crucifixion* (detail). The soldiers sharing out Christ's clothing at the foot of the cross each display different facial characteristics, but share the common feature of precious clothes woven with gold thread.

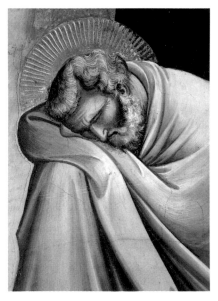

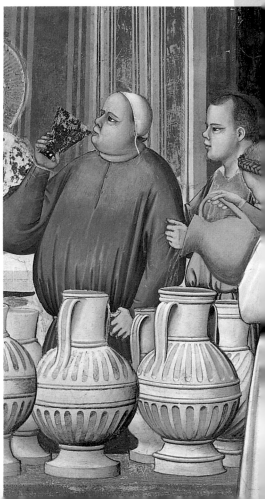

■ *Marriage at Cana* (detail, right). The figure of the obese man is perhaps the most characterful study in the cycle, and may be the portrait of a real person. The red tunic covering his body reveals a distended abdomen

and his head looks as though he has no neck. Giotto wryly chose to portray him in the act of raising a goblet to his lips and placed a number of wine vessels in front of him in the foreground, their shape accentuating his rotundity.

Lamentation

Jesus' life on earth ends with this tragically intense representation, in which human suffering and divine mystery acquire a cosmic dimension. The colors, based on livid tones, contribute to the supreme unity of the whole.

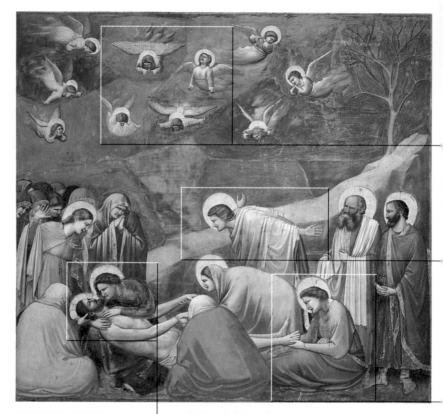

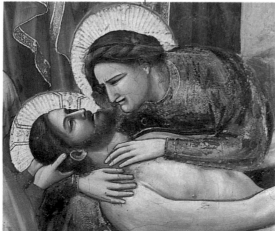

■ The faces of the Madonna and Jesus, close enough to brush against one another, are the focal point in a composition in which all the imaginary lines of composition converge. The Madonna's face and her pose express the essence of an intensely human sorrow.

■ Sharing in the sorrow which is shown in the lower part of the composition, equivalent to the historical and real space, is a host of angels shown with expressions of despair. Each of these appears to be suspended in sharply foreshortened flight positions, their faces and gestures clearly defined, their garments blending into the blue of the background.

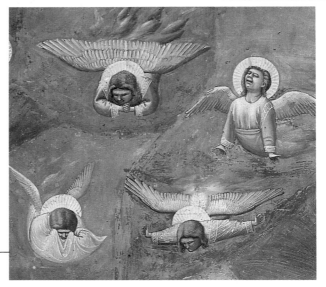

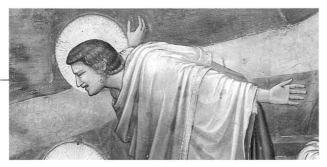

■ Despair is expressed by all the different figures. St John, kneeling with his arms opened out behind him in a gesture which measures space, is the most isolated figure. He, too, is positioned diagonally, like the rock in the background; his face is young and contorted by pain, his body wrapped in a cloak which confers an element of solemnity to the figure.

■ Mary Magdalen, seated on the ground, supports Jesus' crossed feet, her head bent forward, her face sorrowful, her back hunched in despair. This is a further portrait of grief, which is extremely delicate and intensely feminine.

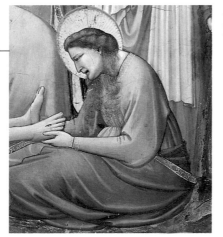

Franciscan Monk

Scholars disagree about the date and attribution of this panel in the Berenson Collection, formerly in Settignano and now at Harvard, but recent studies have acknowledged it as Giotto's work, dating it after 1300.

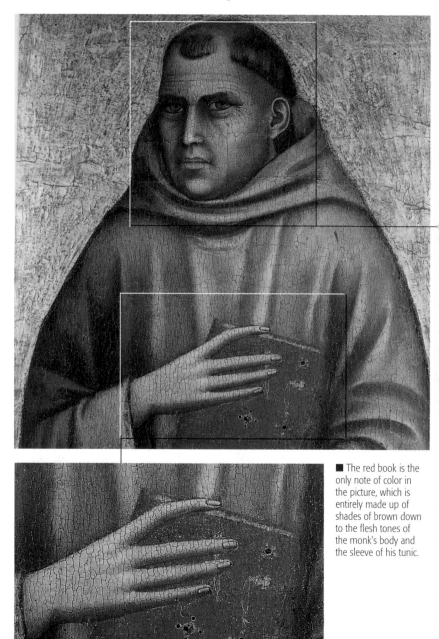

■ The red book is the only note of color in the picture, which is entirely made up of shades of brown down to the flesh tones of the monk's body and the sleeve of his tunic.

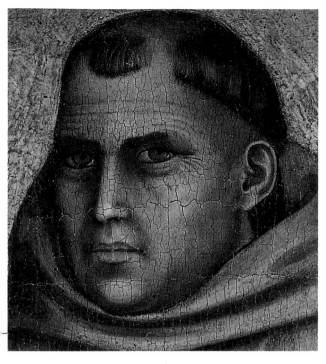

■ The monk's features and his expression are so meticulously described as to suggest that this could have been the portrait of a real person. The head summarizes the monumentality of the whole figure, which has a strong but delicate rounded outline. The curve of the man's profile is echoed by his circular tonsure and the fold in his hood. His face is full, its roundness conveyed by means of various shades of brown.

■ Also in the Berenson Collection is this panel, which is probably part of a series originally from a Franciscan church. A study of this work suggests it is by Giotto's workshop, whose artists may have executed it around the same time as the Padua frescoes.

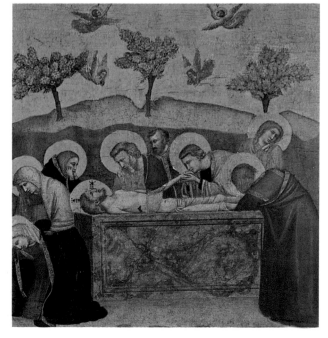

Giotto's assistants

■ Giotto workshop,
Last Supper, 1306–10,
Alte Pinakothek, Munich.
This is one of a series of
small panels that can be
attributed entirely to the
workshop, even though
they make use of
certain elements found
in the Padua frescoes.
The gallery, for instance,
is a reworking of the
one depicted in
Marriage at Cana.

After the Arena Chapel frescoes, the attribution of Giotto's works becomes more doubtful, fuelling speculation about the structure of his workshop. Although the question applies to his entire output, the supreme achievement of the Assisi frescoes and the Padua cycle earned Giotto a fame which led to commissions from a wide and prestigious clientele. The artist thus became the head of a major artistic "business", which employed dozens of artists recruited mainly in Florence where Giotto spent most of the first three decades of the new century. Some panels painted during these years display compositional elements that are clearly in line with the master's own ideas but they are stylistically less confident and more modest in their execution. They reveal a tendency to show the figures in a rather rigid way, almost invariably depicted from the front. They also lack a sense of space, which was the novel element in Giotto's style. The so-called workshop works also display a few archaic elements in the definition of forms, as well as a certain harshness in their draughtsmanship. These doubtful works include a series created for the Ognissanti Church in Florence, with the exception of the *Madonna Enthroned* altarpiece, which is attributed to Giotto alone, working without assistance.

■ Giotto?, *Dormition
of the Virgin*, 1315–25,
Gemäldegalerie, Berlin.
This panel is attributed
to Giotto although with
some doubt because of
the uneven artistic
quality of its different
parts. The central group
and a few angels on the
right appear to be more
skilfully executed,
whereas other less
successful figures seem
to have been executed
by the workshop.

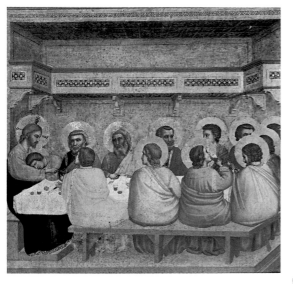

■ Giotto workshop,
Crucifixion, c.1320,
Alte Pinakothek, Munich.
This painting (below)
appears to be a
simplified variant
of the Padua *Crucifix*
but it reveals a rather
heavy touch by the
artist and a certain
repetitiveness in the
faces of the figures.

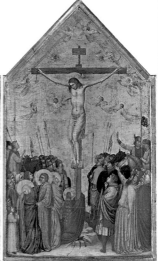

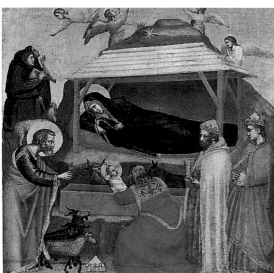

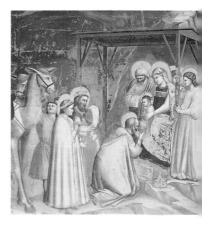

■ Giotto workshop,
Adoration of the Magi,
1306–10, Metropolitan
Museum, New York.
The panel is a synthesis
of the Padua *Adoration
of the Magi* and *Nativity*:
the hut, the pose of the
Madonna, and the Magi,
here placed on the right.

■ The reference to the
Adoration of the Magi
in the Arena Chapel
is clear. There is an
obvious qualitative
difference between
the treatment of space,
the portrayal, and the
overall tone, which is
much more sensitive.

Madonna Enthroned

This panel in the Uffizi is one of the major masterpieces in the development of Giotto's style and in his revival of traditional iconography. It can be dated to the early 1320s.

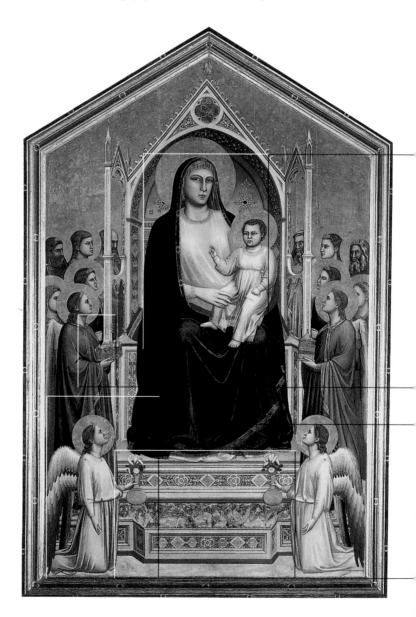

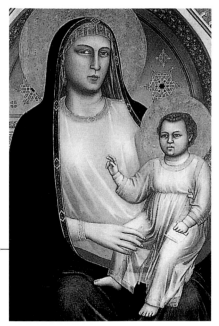

■ Giotto gives the Madonna a slightly rotating movement, which is echoed by the position of the Child. The classical imprint is clear both in the Virgin's perfectly oval face and in the monumentality of her body, which is gigantic in relation to the angels and is in keeping with a medieval hierarchical canon.

■ The kneeling angels appear to be delicately agile in their luminous garments, their solemn, intense gaze directed at the Madonna. Each carries a vase of roses and lilies, flowers that belong to the Marian tradition, and painted with a remarkably lifelike freshness

■ The crown held by the angel is a finely worked jewel which is typical of Giotto's care over objects and how they are made. Here, the crown also fulfils a symbolic function in relation to the Madonna's majesty.

■ The ample throne, perfectly balanced in relation to the size of the Virgin, rests on an elegantly decorated platform with classical-type motifs that recalls the decorative framework in the Arena Chapel.

BACKGROUND

To Rome for Cardinal Stefaneschi

Among the many works attributed to Giotto, the *Navicella* mosaic *(Christ Walking on the Water)*, now lost but very famous in its day, is of particular interest, both in itself and because it provides us with the opportunity to examine the period in the history of the city of Rome to which it refers, and the background of Cardinal Jacopo Stefaneschi, who commissioned it. Giotto may have travelled to Rome toward the end of 1313, summoned by the powerful cardinal to execute the mosaic for the façade of St Peter's. The work, which illustrates the story in Matthew relating how Peter was saved by Jesus as he walked on water, refers to God's protection of the church and the pope. The subject was justified by the crisis the Roman church was undergoing during the Avignon period when, following the papacy's defeat by the French monarchy, Pope Clement V moved the papal seat to Avignon under the protection of Philip the Fair. The deeper question was a definition of the relationship between spiritual and temporal power, which had seen papacy and empire drawn into a secular conflict that had been both politically and ideologically motivated. During the years of "Avignon captivity", Cardinal Stefaneschi was in charge of Rome for a short time and used culture as a means of re-establishing papal power and so employed Giotto, the most famous artist of his day.

■ The *Navicella* mosaic was destined for the façade of St Paul's, the southern wall of which is shown below. In the atrium of the present-day basilica all that survives of the work can be seen.

■ Giotto, *Angel*, San Pietro Ispano, Boville Ernica. The angel may be part of a fragment of the original *Navicella* mosaic, for which sources suggest Giotto provided the cartoon. Besides its solid structure and the lifelike quality of the figure, the delicate, luminous use of color typical of the artist is visible.

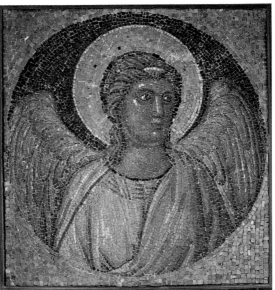

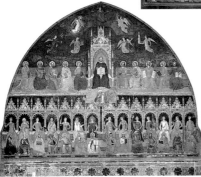

■ Andrea Bonaiuti, *Triumph of St Thomas Aquinas,* Spanish Chapel, Santa Maria Novella, Florence. Andrea Bonaiuti was among the first to refer to the *Navicella* mosaic in these frescoes. In the current decoration, however, no trace of it remains.

■ Parri Spinelli, copy of the *Navicella* fresco (below). All that survives of the *Navicella* does not enable a proper interpretation of it. The drawings inspired by it show a marine landscape with the ship in the foreground and Christ supporting St Peter on the right.

■ St Peter's Basilica, Rome.

1306–1315

The Peruzzi Chapel

Much of Giotto's mature years were taken up by his work on the Santa Croce Basilica in Florence, where he was commissioned to decorate the chapels of some of the city's most powerful families. Firm evidence of this daunting task survives only in the Peruzzi and Bardi Chapels, and the Peruzzi Chapel in particular is of a very high artistic standard, which points to a further progression in Giotto's treatment of space. The exact date of the commission is unknown, but work may have begun in the late 1320s. The subject, arranged in three horizontal tiers, illustrates three episodes from the life of John the Baptist and three from the life of St John the Evangelist. The frescoes are in a poor state of repair, partly because they were painted using the *a secco* instead of the proper *buon fresco* technique. In spite of this, the majestic concept of space can still be appreciated, perceived as a concrete, airy entity, represented by illusion in a way that seems to convey its full scope. Overall, the tone of these frescoes is more sober than that of previous ones, going beyond the Gothic in their adherence to the specifically Florentine tradition.

■ Giotto, *Raising of Drusiana* (detail, above). The background is no longer a means to define the place in which the scene is set, but reveals a consistency that ensures its autonomy, giving it the same importance as the figures depicted.

■ Giotto, *St John on Patmos* (detail). The figures in the Peruzzi frescoes appear imposing, almost in anticipation of Renaissance art. This work reveals a delicate, subtle use of color.

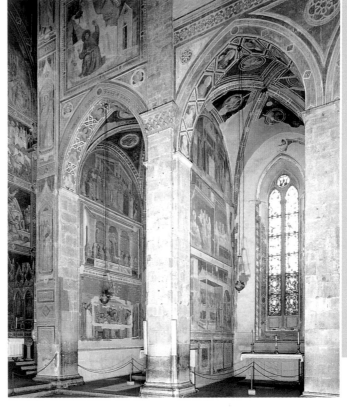

■ The Bardi and Peruzzi Chapels (right). The Peruzzi Chapel is in the second right-hand transept, looking down from the apse. The banker Donato Peruzzi had it built in 1299, requesting that it be inspired by a sober, severe spatial depth in keeping with the rest of the church.

■ Lorenzo Ghiberti, (stone panel, Baptistry, Florence, c.1450) was the first to document Giotto's activity in Santa Croce.

■ The basilica of Santa Croce is attributed to Arnolfo di Cambio, who probably built it from 1294. It is one of the finest examples of Italian Gothic architecture.

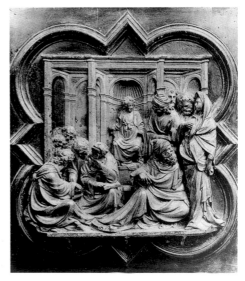

Feast of Herod

This fresco shows two separate events during Herod's feast: Salome's dance in the central area, and the handing over of John the Baptist's head in the side area. The work has been poorly preserved, but its structure is intact.

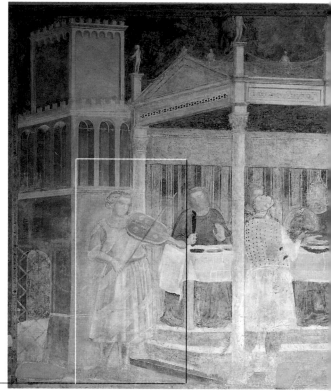

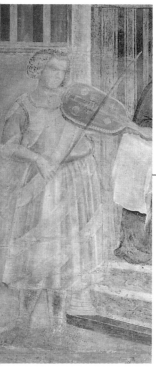

■ The figure of the musician, which recalls the Padua frescoes, displays a greater solidity and spatial consistency than the others. The instrument has been painted in minute detail.

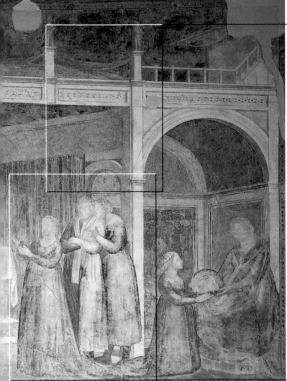

■ All the frescoes in
the Peruzzi Chapel are
somewhat simplified,
harking back to classical
models both in the style
of their proportions,
and in the restrained
decorative elements.

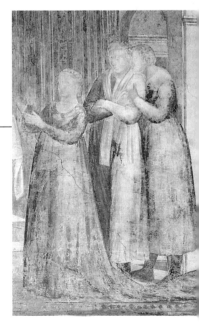

■ In the portrayal of
the feast, the viewpoint
appears to be
foreshortened, enabling
the viewer to see
it more easily. In this
sense Giotto moves
away from traditional
perspective, which
includes geometric and
frontal views, in order to
express a more dynamic
conception of space.

■ The group of women
was used by Ambrogio
Lorenzetti in his frescoes
at San Francesco in
Siena in 1328, evidence
of the fame enjoyed
by the Peruzzi frescoes
in their day.

Giotto, *Mary Magdalen Speaking to the Angels* (detail), Lower Church, Assisi.

1315–1325

Art and history at the dawn of a new century

■ Orvieto, cathedral, 1290–1330. The façade was created by Lorenzo Maitani in the Gothic manner, as can be seen from the powerfully vertical elements and the sumptuous decoration, which were a novelty in Tuscan architecture of the day.

Coming as it did after the medieval millennium, the fourteenth century was a period during which many trends that had got underway during the previous century came to their full fruition. It was also a time that saw evidence of decadence and great change. The death of Frederick II in the mid-thirteenth century and the subsequent Ghibelline defeats had created a crisis for the empire but the papacy, too, was obliged to come under the control of the French sovereign and move its seat to Avignon despite its apparent victory, sealed by the Boniface VIII's papal bull *Unam Sanctam*. Once the battles between Guelphs and Ghibellines had abated, Italian cities consolidated the role played by their merchant and craft guilds, which were fundamental in the century's history and economy. Many cities progressed to the status of signories. The fourteenth century was also the century that saw the birth of the Italian literary tradition: Dante, Petrarch, Boccaccio became the models for a whole new expression and style, moving away from the medieval figurative language and laying the foundation for a new civilization characterized by an inherent social and economic dynamism. This climate led to a new definition of man's place within history and his relationship with God that would culminate in the beginnings of humanism.

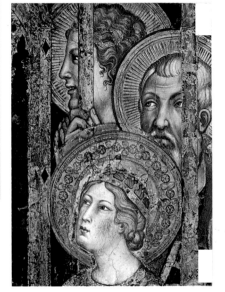

■ The Papal Palace, Avignon, 1334–52. One of the most imposing civil buildings of the Gothic age, it was conceived as a fortress. The current building is the result of changes made to the original construction.

■ Simone Martini, *Maestà* (detail, below), 1315, Palazzo Pubblico, Siena. This work expresses the courtly and aristocratic quality of Gothic art. The affinity with goldwork is clear, shown in the detail on the halos, which appear to be finely chiselled.

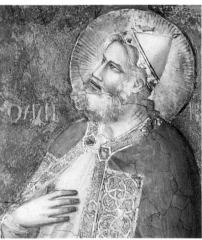

■ Giotto?, *David* (detail), Lower Church, Assisi. The figure reveals both the solid physical

quality typical of Giotto and a certain precious vagueness, typical of courtly Gothic.

■ Tino di Camaino, *Monument to Arrigo VII*, 1312–15, Camposanto, Pisa. The legacy of thirteenth-century sculpture influenced many artists including sculptor Tino di Camaino who, having trained with Giovanni Pisano, translated the master's powerful, tormented language into more tranquil terms with compositions that utilize wider planes.

111

The Magdalen Chapel

This chapel in the Lower Church at Assisi, commissioned by Teobaldo Pontano, houses another important fresco cycle, which has been the object of much debate among scholars. The frescoes are almost unanimously attributed to Giotto, although their date remains controversial. They may have been executed between 1315 and 1318, a period during which Giotto does not appear to have been in Florence. The frescoes cover the entire cross vault and the walls, arranged, as elsewhere, into tiers that are framed by decorative bands with mosaic patterns. The scenes from the life of Mary Magdalen are inspired by Jacopo da Varagine's *Legenda Aurea* and occupy the lunettes and the middle band of each wall. Their iconography is complex, blending the themes of sin, conversion, and feminine saintliness.

The most novel element lies in the sweeping, desolate landscapes, which are almost more central to each scene than the figures who are shown in reduced proportions, far removed from the monumentality of the Padua frescoes. The spatial dimension, elsewhere viewed as the most important feature, here takes second place to color and luminosity and the elegance of the overall tonal harmony.

■ Giotto, *Noli me tangere*. This scene, a sober balance between figures and landscape, reveals a very delicate and expressive handling of color.

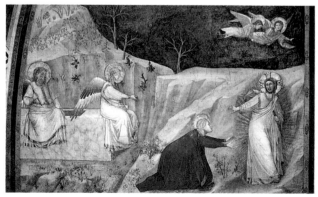

■ Giotto, *Supper in the House of the Pharisee* (detail). The delicate, luminous quality of the long blond hair is conveyed through the use of light and with delicate brushstrokes.

■ On the vault, within four roundels, are the heads of *Christ Giving his Blessing, Mary Magdalen, Martha,* and *Lazarus.* Next to the vaulting cells in the lunettes on the walls are the final episodes of the scenes, which are here read from bottom to top.

■ The interior of the Church of St Mary Magdalen at Vézelay. This church (1040–50) incorporates a blend of Romanesque and Gothic features in the round arches of the nave and in the dynamism of the pointed arches within the apse.

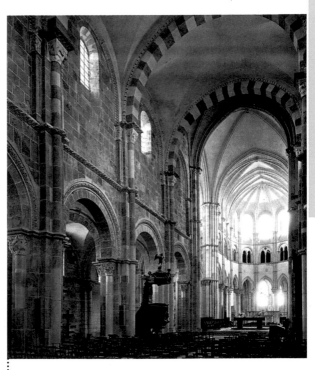

■ Alongside the arch leading through to the next chapel is *Mary Magdalen with Cardinal Pietro di Barro.*

The cult of Mary Magdalen

The identity of Mary Magdalen is complex and made up of different elements from various parts of the Bible. She is generally seen as the penitent sinner who dries Jesus' feet with her hair and receives his forgiveness although Mary, the sister of Martha and Lazarus, and one of the pious women who found the empty tomb of Jesus, was also identified with the saint, a view first endorsed by Pope Gregory the Great. The cult of Mary Magdalen, upheld throughout the Middle Ages, became particularly widespread in 1279 when Charles II, the future king of Naples, believed that he had found her body in the crypt of the church of St Maximin in Provence.

The Miraculous Landing at Marseilles

The scene combines the arrival of Mary Magdalen in Marseilles with one of her miracles. The bird's-eye view is a new one, affording the viewer a broader vision of the unusual marine landscape.

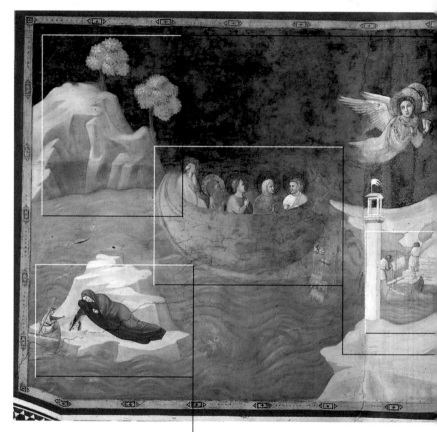

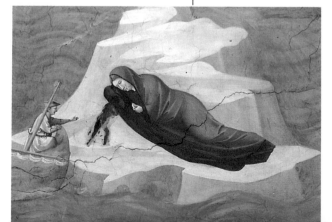

■ This detail shows the miracle: a merchant had been forced to abandon his sick, pregnant wife on a small island. On his return, expecting to find her dead, he sees she is cured. Note the skilful use of color in the treatment of the woman and the rock.

■ The rocky landscape with small trees recurs, almost as a leitmotiv, throughout Giotto's cycles with few variations. Here, set between sky and sea, it is charged with a feeling of silence and distance.

■ The boat carrying Mary Magdalen and her companions (below) seems large in relation to the rest of the scene. This is due to the medieval custom of portraying a figure proportionally larger if they express spiritual significance.

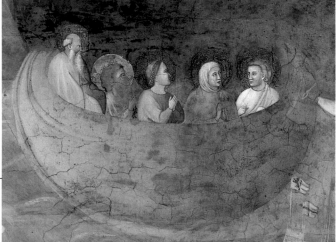

■ The scene is enchanting in its lively narrative. The eye rests on the moored boats and in the portrayal of the everyday activity taking place around them on the sinking sailing boat and on the outline of the coast.

The Lower Church at Assisi

Many different artists were involved in the decoration of the Lower Church at Assisi, confirming the pivotal role of the Assisi complex as both a spiritual centre and a historically important artistic workshop. The decorative scheme of the Lower Church hinges on a new concept of the role played by the powerful Franciscan order, which was based on the thoughts and predictions of the Calabrian monk Gioacchino da Fiore. In his vision of the world as the image of the mystery of the Trinity da Fiore had gone beyond the Augustinian stance which was based on the correspondence between the Old and the New Testament, subdividing the history of humanity into three great periods, corresponding to the Trinity. His vision, despite being condemned by the church, was widely favored by the Franciscans and influenced their iconography, as can be seen in the vault above the altar of the Lower Church where St Francis is shown as part of the glorious kingdom of God, which humanity can access through his mediation. It is possible that Giotto may have been the inspiration behind the decoration of the entire Lower Church.

■ Pietro Lorenzetti, *Crucifixion*. Lorenzetti's work in the southern transept can be dated to about 1316–17 and is of great historical and artistic significance, not least for the comparison between Sienese artists and the Florentine School, which was depicted on the northern transept.

■ Giotto and Parenti di Giotto, *Crucifixion* (detail), Lower Church, Assisi. This affinity with Giotto's style suggests some frescoes may have been painted by the so-called Parenti di Giotto.

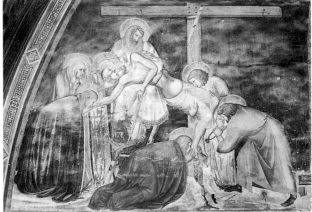

■ Master of the Vele (Vaults), *Franciscan Allegories*. Three of the vaults show *Obedience, Chastity,* and *Poverty,* and the fourth *St Francis in Glory*: carried up to heaven on a throne borne by angels, he is shown clean-shaven, in accordance with early Christian iconography.

■ Simone Martini, *Scenes from the Life of St Martin* (detail). Simone Martini, another Sienese artist who was active in Assisi around 1215, translated the classical structure of Giotto's draughtsmanship into the elegant preciosity of Gothic culture.

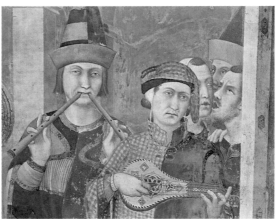

■ Giotto or Parenti di Giotto, *Christ among the Doctors*. From the *Scenes from the Life of Christ*, executed in the northern transept. The perspectival effect in the temple at Jerusalem anticipates fifteenth-century perspective.

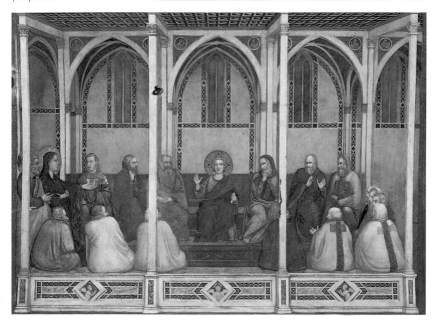

The Stefaneschi Altarpiece

This altarpiece, another great work of Giotto's, was probably painted in 1320. Commissioned by Jacopo Stefaneschi, it was destined for the high altar of St Peter's Basilica. Giotto was in Rome, working on prestigious commissions from, among others, Lorenzo Ghiberti. The central front panel of this altarpiece, which is painted on both sides, shows *St Peter Enthroned*, sumptuously clad in papal garb, with the two donors Cardinal Stefaneschi and Pope Celestine V, and two pairs of saints occupying the side panels. The back, which is more complex, shows *Christ Giving His Blessing* at the center with, at the sides, the *Crucifixion of St Peter* and the *Beheading of St Paul*. The altarpiece thus focuses on the Petrine theme with a view to glorifying the papacy, a subject-matter which explains the sumptuous and symbolic feeling of the work down to the use of such archaic devices as the concept of single figures and the overall structure of the altarpiece as a whole. Once again Giotto demonstrates his skill in adapting his style to the requirements of the commission without ever sacrificing the high quality of his artistic expression.

■ Giotto, *Stefaneschi Altarpiece (recto)*, Pinacoteca Vaticana, Rome. The precious character of this work (below left) lies in the profusion of gold, the choice of colors, and the unusual contrasts.

■ Master of the San Giorgio Codex, *Initial with Cardinal Stefaneschi,* Biblioteca Vaticana, Rome. Stefaneschi's rich iconography underlines his political weight.

■ Simone Martini, *St Clare,* Lower Church, Assisi. Giotto was undoubtedly influenced by Martini's figures at the time when Martini was working on the Chapel of St Martin and Giotto on the Magdalen Chapel.

■ Giotto, *Stefaneschi Altarpiece* (*verso*), Pinacoteca Vaticana, Rome. The altarpiece's structure, similar to a reliquary, appears to be fully Gothic in tone. This is particularly evident in the front side (below right): a vertical arrangement prevails, as well as a sacred effect.

■ San Giorgio al Velabro, Rome. Cardinal Stefaneschi was the incumbent of this church, dedicated to St George, so the saint is also shown as donor in the central panel of the polyptych.

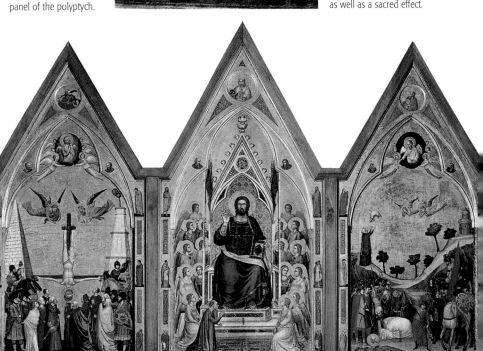

1315–1325

Madonna and Child

Probably executed during the early 1320s, this altarpiece was made up of five panels, four of which are in different museums. This work in the National Gallery of Art, Washington, is attributed to Giotto.

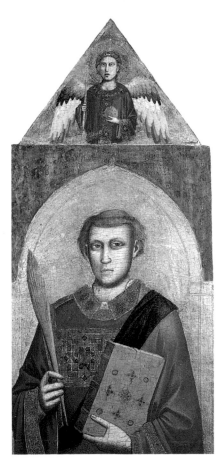

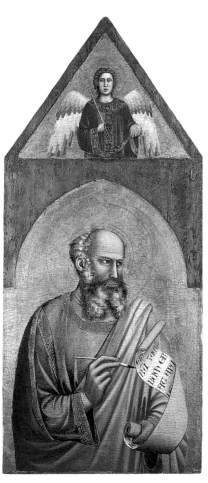

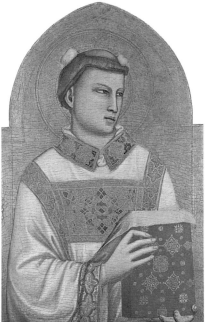

■ *St Lawrence*, Musée Jacquemart-André, Châalis. The figure stands out starkly against the gold background, the deep red of the dalmatic and the green of the book providing a strong contrast. The facial features recall Giotto's more youthful phase.

■ *St Stephen*, Horne Museum, Florence. The artistic achievement of this panel consists mainly in the confident way in which the figure is drawn and in the comfortable balance between the colors. An elegant tone, which anticipates courtly paintings, can be discerned.

■ *St John the Evangelist*, Châalis, Musée André-Jacquemart. The similarity with *St Lawrence* is evident. This panel appears to be more powerful, however, suggesting it was executed at a different time.

Giotto, *Death and Ascension of St Francis* (detail), Bardi Chapel, Santa Croce, Florence.

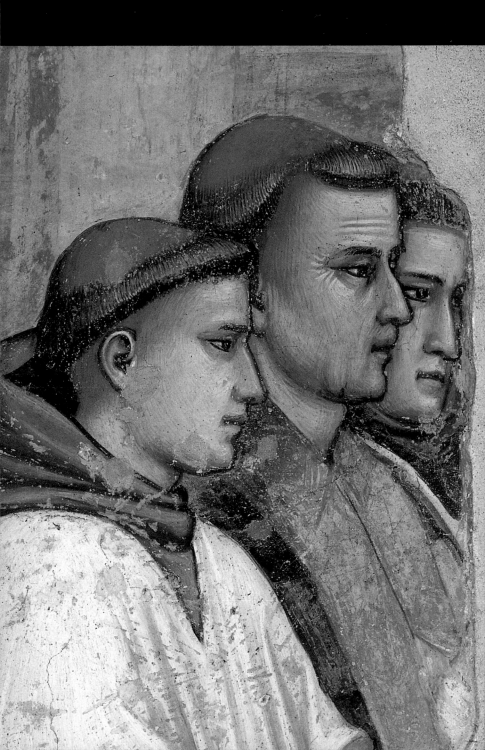

The Bardi Chapel

The decoration of the Bardi Chapel in Santa Croce makes up Giotto's last great fresco cycle and once again illustrates the life of St Francis. The scenes are subdivided according to the usual tier arrangement: *Renunciation of Worldly Goods, Confirmation of the Rule, Apparition at Arles, St Francis Before the Sultan (Trial by Fire), Death and Ascension of St Francis, Vision of the Ascension of St Francis*. Comparisons with the Assisi cycle are inevitable and immediately reveal the immense difference in their execution: space here, as in the Peruzzi Chapel, appears to be viewed from the observer's vantage point and widens into increasingly ample fields, characterized by monumental architectural elements which draw the composition together into a single unit rather than subdivide it into separate plastic areas. The portrayal of the figures is also different: they appear to be interconnected in a gentler way, their facial features and gestures flowing within a totally lifelike rhythm of continuity. They are also more elongated and slender, a stylistic device Giotto had introduced in the Magdalen Chapel frescoes, in which the same muted and refined color tones recur in this cycle.

■ Florence, Santa Croce, interior. the succession of pointed arches gives the basilica space in a consummate expression of Florentine Gothic. The Bardi Chapel is the first on the right of the presbytery.

■ Giotto, *Renunciation of Wordly Goods*. This cycle has been dated after the Peruzzi frescoes, and just before Giotto's departure for Naples in about 1325.

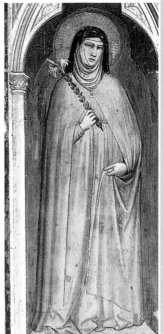

■ Simone Martini, *St Clare,* Chapel of St Martin, Assisi. This work is very similar to the figure on the right, painted by Giotto.

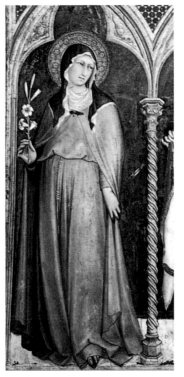

■ Giotto, *Death and Ascension of St Francis* (detail). Painted in the lower tier, this scene focuses on the community of friars, who take up the entire area, gathered around St Francis. The detail captures the drama of the scene and highlights the elegant variations in color.

■ Giotto, *St Clare.* The saint is painted with two other Franciscan saints on the lower wall of the chapel and appears to be framed within an elegant Gothic pointed arch.

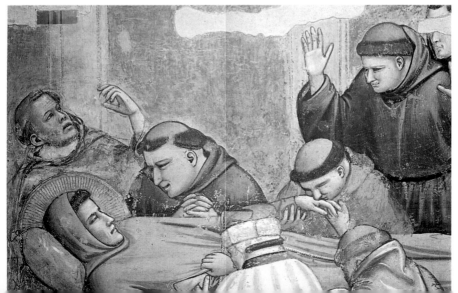

The court of Robert of Anjou

■ Tino di Camaino, *Mausoleum of Mary of Hungary*, Santa Maria Donnaregina, Naples. Tino di Camaino was widely imitated by southern Italian sculptors.

■ Castel Nuovo, Naples. Built by Charles I of Anjou between 1279 and 1282, it was rebuilt into its present structure by Ferdinand of Aragon in 1442. Many documents list payments to Giotto for the frescoes and two chapels, the Palatine one and the so-called Secret Chapel.

■ Santa Chiara, Naples. Giotto may have worked on the church of Santa Chiara. Shown here (right) is the eighteenth-century cloister of the Poor Clares.

The kingdom of Naples passed from Swabian dominion to Anjou rule in 1266 and was governed during the first half of the fourteenth century by Robert of Anjou, known as Robert the Wise. The Anjou kings, fearing that any local initiative could be counter-productive, considered it safer to entrust the running of various different aspects of the kingdom, including economic and cultural matters, to outside sources. Because of this, and a complex background of political intrigue, Robert found a wealth of experience in Tuscany, which accounts for the presence at the court of Naples of businessmen such as Boccaccio's father, literary figures such as Petrarch, and artists of the calibre of Giotto, the Roman Pietro Cavallini, and Tino di Camaino. While this prevented the development of a local artistic school in Naples, the city nevertheless became a thriving center for the most modern cultural trends of the day. This climate was expressed, architecturally, in the churches of Santa Maria Donnaregina and Santa Chiara, while the Sienese Tino di Camaino developed the sepulchral style which had been introduced by Arnolfo di Cambio in his mausoleums of Catherine of Austria and Mary of Hungary, Robert's daughter-in-law and mother. No trace of Giotto's activity in Naples has survived but we do know that he was made court painter in 1330. It was in this capacity that he worked in Castel Nuovo, the seat of the Anjou court.

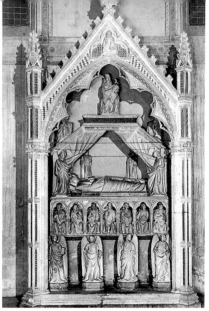

■ A picture of Petrarch (Francesco Petrarca). Petrarch was at the court of Robert of Anjou in Naples in 1340, where he read out a few pages of his poem *Africa*, a work for which he was crowned poet laureate the following year in Rome.

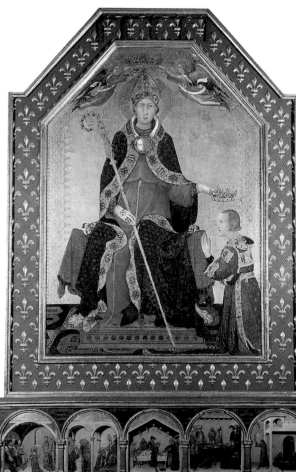

■ Simone Martini, *St Ludovic of Toulouse Crowning Robert of Anjou,* 1317, Capodimonte, Naples. Simone Martini also painted for Robert of Anjou, although he presumably never lived in Naples. With this commission, the king sought to justify his accession to the throne, which took place after his brother Ludovic abdicated in order to embrace monastic life.

Milan under the Visconti

Evidence exists that between the period he spent in Naples, and his final return to Florence, probably between 1335 and 1336, Giotto was for a brief time in Milan. There is no trace of his activity at the Visconti court, but the influence he brought to bear on many Milanese works both of the time and of the period shortly afterward, such as the *Crucifixion* of San Gottardo in Corte or the frescoes in the Chiaravalle Abbey, is unquestionable. In 1342 the Milanese historian Galvano Fiamma described a room in Azzo Visconti's palace, now the Palazzo Reale, which was magnificently painted with figures from Greek mythology. It seems highly likely that these were works painted by Giotto and it is unusual that for the first time the artist turned to the classical world for inspiration. Being part of the court, Giotto was obliged to celebrate the Visconti lord and adapt his usual style in order to cater for the taste of the Visconti, who were particularly partial to French ways. His frescoes were thus enriched with gold, blue, and enamel, and made use of new techniques that were akin to the decorative arts, highly effective and no doubt very pleasing to his masters.

■ Palazzo Reale, Milan. The large mullioned brick window is one of the very few elements that survive of the original building.

■ Giovanni di Balduccio, *Tomb of Azzo Visconti,* San Gottardo in Corte, Milan. The sarcophagus below shows the cities that were part of the Visconti dominion, each with their patron saint: above them is the statue of the reclining Azzo, watched over by angels bearing his shroud.

■ San Gottardo in Corte, Milan. The church was built as a court chapel, annexed to the Visconti palace and completed in 1336. A typical example of Lombard Gothic, it was built in brick, with high, pointed mullioned windows. The interior has been extensively reworked.

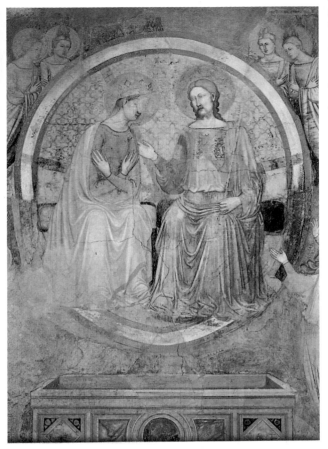

■ Giotto School, *Coronation of the Virgin*, Abbey, Chiaravalle. This fresco belongs to a cycle painted in the lantern of the abbey at Chiaravalle and dates from about 1340. It shows the influence of the Tuscan, and particularly the Giottesque figurative style in Lombardy.

■ *Crucifixion*, San Gottardo in Corte, Milan. This fresco is so faded it is little more than a shadow but some of the clearer faces suggest the style of the so-called Parente di Giotto, taken up by a Lombard assistant.

The Baroncelli Altarpiece

One of Giotto's late works, which may perhaps date from a time before his journey to Naples, this piece is housed in the Baroncelli Chapel in Santa Croce. Signed *opus magistri Jocti*, it is believed to be by Giotto and his assistants, particularly the altar painting. Made up of five ogival, multifoiled panels and encased in a Renaissance frame, it shows the *Coronation of the Virgin* in the center with a choir of angels and saints in the side panels who appear, falsely, to be contained within one, overall, single space.

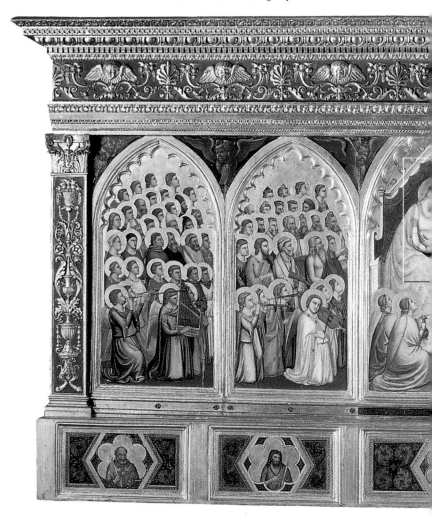

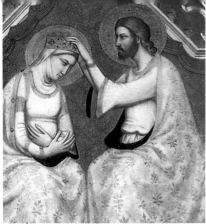

■ Mary and Jesus sit on a throne which is covered by a simple green drape. They wear light pink robes over white tunics. The balance between the colors and the way in which they are enhanced by the light is particularly delicate. The faces introduce a new typology: small heads and elongated eyes, typical of Giotto's late works and evidence of the Gothic influence. The panel appears to be pared down to the most essential elements and is compositionally very balanced. Here Giotto tones down his concern with the rendering of space without in any way sacrificing the originality of his painterly language.

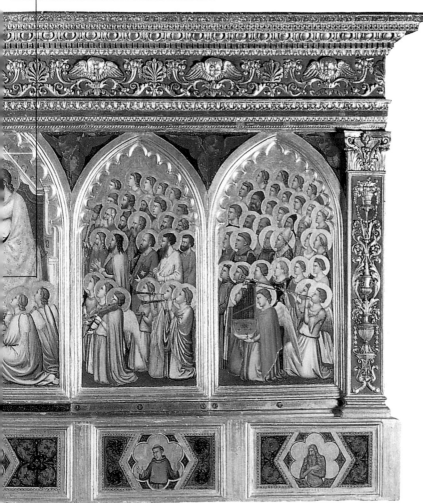

Giotto the architect

The belief that Giotto was also an architect is supported by fourteenth-century sources and backed up by Vasari, who described him as "sculptor and architect". More concrete evidence lies in his appointment in 1334 as *magister e gubernator* (chief architect) of the workshop of Florence cathedral. Despite all this, there is no real certainty that he worked as an architect, although his concern with space throughout his painting, invariably worked out in extraordinarily original terms, is a crucial argument in favor of the theory. The building of the Arena Chapel, similar in its pared-down outlines and classical proportions to many buildings painted by the artist, is also attributed to Giotto. A later project was the Carraia Bridge, opened in 1337 and no longer extant, for which he may have been responsible in his capacity as chief architect. This revealed an advanced technique and simplicity of structure typical of Giotto. Firmer evidence lies in the Campanile in Florence. This was conceived as a square edifice, with a strong octagonal column smoothing each corner and giving the whole bell-tower an effect of massive solidity. The geometric clarity and decorative style which characterize it make the Campanile a perfect continuation of the great fresco cycles.

■ Giotto, Campanile, Florence. Entirely covered in white, pink, and green marble slabs, the Campanile is perfectly in keeping with the Florentine tradition and the nearby cathedral and baptistry.

■ The base of the Campanile, resting on a platform that was built following subsidence in the ground, is decorated with reliefs inside hexagons which are contained within pink marble sections.

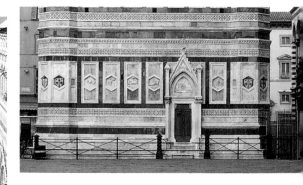

■ Giotto, Arena Chapel, Padua. The consummate simplicity of the building, with the three-mullioned window on the façade, the single nave inside, and the large barrel vault, suggests it was deliberately conceived in this way as a foil to the elaborate decoration of the interior.

■ Giotto, *The Meeting at the Golden Gate* (detail, below). The Carraia Bridge seems to be the culmination of an idea which had already been formulated in the bridge in this fresco in the Arena Chapel, which suggests that Giotto may have been its creator. The Roman bridge at Rimini has also been suggested as a source.

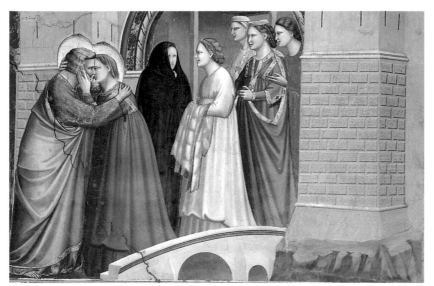

■ Giotto, Carraia Bridge, Florence. This is what the bridge looked like before it was destroyed by enemy action in 1944. It is made up of depressed arches, which rise toward the center.

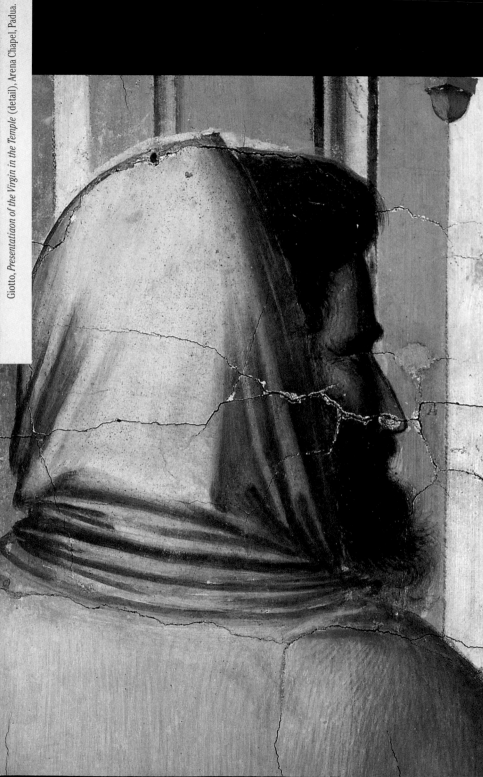

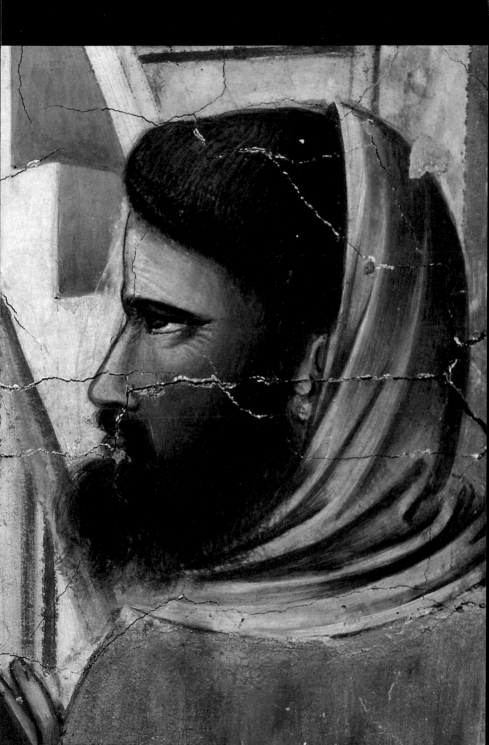

■ Giotto, *St Francis Before the Sultan (Trial by Fire)* (detail), c.1325, Bardi Chapel, Santa Croce, Florence.

Note

The places listed in this section refer to the current location of Giotto's works. Where more than one work is housed in the same **place**, *they are listed in chronological order.*

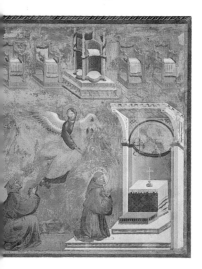

■ Giotto and assistants, *Vision of the Thrones* , 1288–92, Upper Church, Assisi.

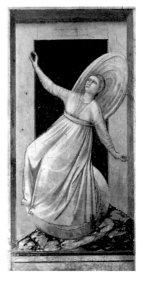
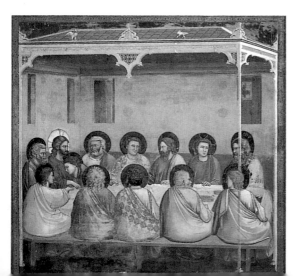

■ Giotto, *Last Supper*, 1302–05, Arena Chapel, Padua.

Note

All the names mentioned here are artists, intellectuals, businessmen, and politicians who had some connection with Giotto, as well as painters, sculptors, and architects who were contemporaries or were active in the same places as the artist.

Alberti, Leon Battista (Genoa 1406–Rome 1472), Italian architect and architectural theorist. A key figure in the Italian Renaissance, Alberti advocated a return to antiquity and followed this principle in his own work, p. 62.

Arnolfo di Cambio (Colle Val d'Elsa c.1245–Florence 1302), Italian sculptor and architect, he began by following the example of Nicola Pisano, and moved subsequently toward a modern type of classicism. He studied works from antiquity in Rome and developed a style based on sharply observed forms and volumes, pp. 16, 17, 47, 55, 56, 58, 105, 126.

Boccaccio, Giovanni (Florence? 1313–Certaldo 1375), Italian writer. Between 1349 and 1351 he produced the definitive version of his *Decameron*, a collection of 100 tales in which he portrayed the human comedy of the society of his day in the twilight of medieval civilization. A poetic realism and a worldly view of human nature dominates his work, pp. 9, 32, 110, 126.

Bonaventure, Saint (Bagnoregio, Viterbo c.1217–Lyons 1274). Philosopher and theologian. Minister general of the Franciscan order, he wrote the official biography of St Francis between 1260 and 1263, p. 40

Bondone, the man to whom Ghiberti and Vasari, the earliest art historians, attribute Giotto's paternity: Vasari describes him as a poor peasant farmer, p. 8.

Boniface VIII, originally Benedetto Caetani (Anagni, Frosinone 1235–Rome 1303), pope. His pontificate (1294–1303) was a difficult one, both because of problems within the church and the grave situation with the French monarchy, pp. 58, 110.

Brunelleschi, Filippo (Florence 1377–1446), Italian architect and sculptor. A central figure in the Italian Renaissance, he was a keen scholar of antiquity and suggested new planning strategies based on the geometric principles of structures, p. 9.

Bonaiuti, Andrea, known as Andrea da Firenze (active in the second half of the fourteenth century), Italian painter. He painted frescoes in the Spanish Chapel in Santa Maria Novella, Florence, p. 103.

Buscheto (active in Pisa during the second half of the eleventh century and the early decades of the twelfth century), Italian architect and the first to work on Pisa's cathedral, p. 14.

Carraresi, A Paduan family which established a signory that governed Padua almost continuously from 1318 until 1405, when the city fell to Venice, p. 68.

Cavallini, Pietro, known as Pietro de' Cerroni, (details from 1273 to 1308), Italian painter. A key figure in the artistic renewal of the late thirteenth century, only a few certain works of his have survived, pp. 16, 58, 81, 126.

Celestine V, originally Pietro Angeleri da Morrone (Isernia c.1215–Castello di Fumone,

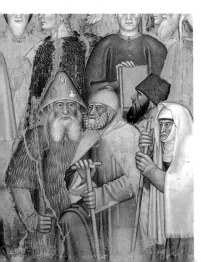

■ Andrea Buonaiuti, *Triumph of the Militant Church*, 1366–67, Santa Maria Novella, Florence.

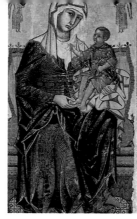

■ Pietro Cavallini,
*Scenes from the Life
of the Virgin* (detail,
Dormition of the Virgin),
c.1296, Santa Maria
in Trastevere, Rome.

■ Coppo di Marcovaldo,
Madonna and Child,
1261, Santa Maria dei
Servi, Siena.

Frosinone 1296), pope. He was
elected on July 5, 1294, but
resigned from the papacy five
months later, p. 118

Cennini ,Cennino (Colle Val
d'Elsa fourteenth–fifteenth
century), Italian painter and
writer. He wrote his *Libro
dell'Arte* in Vulgar Latin at the
end of the fourteenth century.
This is the first true art treatise
ever to be written, pp. 9, 30.

Charles I of Anjou
(?1226–Foggia 1285), king of
Naples and Sicily. With Frederick
II, the greatest monarch of the
thirteenth century: an ambitious
sovereign, he also dominated
most cities in Tuscany,
particularly Florence, pp. 26, 126.

Cimabue, Cenni di Pepo, known
as (information from 1272 to
1302), Italian painter. Active in
Florence and Assisi, but also in
Arezzo, Pisa, and Rome, his work

combines elements of Byzantine
painting, which were still very
relevant at the time, with the
sculptural drama found in works
by the Pisano family. The main
qualities of his art are the
introduction of figures into the
overall space, which is rendered
in a lifelike manner. Gestures
are similarly realistic and always
graceful. Tradition has it that
he was Giotto's teacher, guiding
him towards the more up-to-date
trends of the day, pp. 8, 10, 11, 16,
17, 19, 25, 26, 41, 62.

Clement IV originally Gui
Foulques (St. Gilles – Viterbo
1268), pope(1265–1268). He
assisted Charles of Anjou's
descent into Italy, with the aim
of restraining the Swabians'
power, and was very receptive
to cultural stimuli, p. 26.

Clement V originally Bertrand
de Got (Villandraut ?–Nîmes
1314), pope. He was elected in
1305 and after four years moved
the papal seat to Avignon the
result of interference from
the king of France, Philip the
Fair, p. 102.

Coppo di Marcovaldo (Florence
c.1225–c.1280), Italian painter.
The major exponent of the artistic
trend that developed in Florence
which rejected the following
of Byzantine ways without,
however, giving up their intense
use of color, p. 11.

Dante Alighieri (Florence 1265
–Ravenna 1321), Italian writer.
He turned to poetry early on, with
Beatrice, his muse, who he met
in 1274, providing the inspiration
for his entire poetic output. The
Divine Comedy, a work which
laid the foundation for Italian
literature, is an allegorical poem,
divided into three parts, *Inferno*,
Purgatorio, and *Paradiso*,
pp. 9, 70, 71, 110.

Diotisalvi (twelfth century),
Italian architect. The building
of the lower section of the
baptistry at Pisa, modelled on
the cathedral, is attributed to him,
as is also the church of Santo
Sepolcro in the same city, p. 14.

Donatello Donato di Niccolò
di Bardi, known as (Florence
1386–1466), Italian sculptor. He
was one of the greatest sculptors
of the fifteenth century. During
the course of his remarkably long
career, he worked in a wide range
of three-dimensional and
expressive techniques, p. 9.

■ Donatello, *David*,
1440, Museo del
Bargello, Florence.

■ Lorenzo Ghiberti, *Flagellation*, after 1415, panel on the north door of the Baptistry, Florence.

Duccio da Buoninsegna (details from 1278 to 1318), Italian painter. A pupil of Cimabue, to whom his *Rucellai Madonna* (1285, Uffizi, Florence) was for a long time erroneously attributed, he introduced the new Tuscan trends into Sienese art, integrating them into the city's elegant tradition, pp. 14, 15.

Elias of Cortona (Beviglia, Assisi 1180 –Cortona 1253), Umbrian religious. He is said to have become a follower of St Francis in 1211, becoming involved in the definitive establishment of the order's rule. Pope Gregory IX put him in charge of building the saint's basilica in Assisi, work on which was completed in 1230, p. 22.

Ezzelino III da Romano (? 1194– Soncino 1259), Ghibelline leader of northern Italy. His intuition and political skill, together with his military background, enabled him to hold on to the conquests he had made until his death, pp. 68, 69.

Francesco da Rimini (1330–c.1350), Italian painter. His

work, of which only a few example survive, is full of elements inspired by Giotto, p. 63.

Frederick II (Iesi, Ancona 1194–Castel Fiorentino, Lucera 1250) king of Naples and Sicily (1208), king of Germany(1214), and Holy Roman emperor (1220). One of the most intriguing characters in world history, he was a man of considerable culture, pp. 14, 22.

Ghiberti, Lorenzo (Florence 1378–1455), Italian sculptor, architect, goldsmith, and art writer, his work marks the transition from Gothic to Renaissance culture, pp. 9, 66, 105, 118.

Gioacchino da Fiore (Celico, Cosenza c.1130–San Giovanni in Fiore c.1202), Calabrian monk and mystic. He was a member of the Cistercian order, subsequently founding the hermitage of San Giovanni in Fiore and setting up his own order, p. 116.

Giovanni da Rimini (early fourteenth century), Italian painter. One of the painters of the Rimini School, which

was formed in the wake of Giotto's activity in those parts, he was one of the most receptive to the master's example, p. 62.

Giovanni di Balduccio (Pisa, first half of the fourteenth century), Italian sculptor. A follower of Giovanni Pisano, he moved to Lombardy where he breathed new life into Gothic inspiration, p. 128.

Giusto de' Menabuoi (Florence c.1320–Padua c.1387), Italian painter. An artist in the manner of Giotto, his activity is recorded in Lombardy in 1348 and in Padua in 1370), pp. 67, 69.

Gregory IX originally Ugolino, count of Segni (Anagni c.1170–Rome 1241), pope. He supported the church's independence from the empire and protected the monastic orders, particularly the Franciscan order, p. 22.

Honorius III originally Cencio Savelli (died 1277), pope (1216–27). He tried to continue the program instituted by his precedessor, Innocent III, although Honorius' skills were not as impressive. He is remembered for having confirmed the order of the minor Franciscan friars, p. 30.

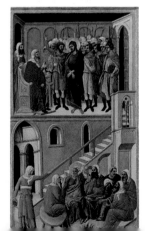

■ Duccio di Buoninsegna, *Maestà* (*verso*), *Christ before St Anne* and *Peter's Denial*, 1308–11, Museo dell'Opera del Duomo, Siena.

■ Giusto de' Menabuoi,
Annunciation (detail),
Baptistry, Padua.

Jacopo da Varagine
(Varazze c.1228–Genoa 1298),
Italian writer. His most important
work is the *Legenda Aurea* or
Legenda Sanctorum, a collection
of the lives of the saints in Latin
(before 1255 or after 1266), p. 112.

Lorenzetti, Ambrogio (Siena
1285–c.1348), Italian painter. The
brother of Pietro, his training was
also influenced by the work of
Duccio and Giovanni Pisano, but
his personality is more eclectic
and difficult to label. The many
artistic experiments he made led
him to achieve an autonomous
and highly original painterly
language, which is unquestionably
one of the most impressive in
fourteenth-century art, pp. 57, 107.

Lorenzetti, Pietro
(1280–c.1348), Italian painter.
His work reveals a knowledge
of Giotto's art, even before he
went to Assisi. His treatment
of space shows a confident
adherence to the master's own
style. He was active mainly in
Siena, also working with his
brother Ambrogio, p. 116.

Maitani, Lorenzo
(Siena?–Orvieto 1330), Italian
architect and sculptor. In 1310 he
was appointed head of the Orvieto
Cathedral workshop, where he
worked until his death, p. 110.

Malatesta, Sigismondo
(Brescia or Rimini 1217–Rimini
1468), lord of Rimini. He
promoted the building of Rimini's
castle and the transformation
of the original church of San
Francesco into the Tempio
Malatestiano, p. 62.

Martini, Simone (Siena
1284?–Avignon 1344), Italian
painter. He painted *Maestà* in his
native city (1315, Palazzo Pubblico,
Siena), but was active in Naples
at the Anjou court and in Assisi,
in the Lower Church, before going
to Avignon. His images are neither
earthly nor completely spiritual,
pp. 57, 117, 119, 125, 127.

**Master of the Montefalco
Crucifix** (early fourteenth
century), Italian painter.

*Saint Cecilia and Scenes from
her Life* (Uffizi, Florence) are
attributed to him and his touch
can also identified in some
of the *Scenes from the Life of
St Francis* in the church
of St Francis in Assisi, pp. 42, 52.

Master of the Vele (Vaults)
(active during the 1440s), Italian
painter. He worked on the fresco
decoration of the Lower Church.
The *Virtues* and *St Francis in Glory*
are attributed to him, p. 170.

Memmo da Filippuccio (early
fourteenth century), Italian
painter. He was probably a pupil
of Giotto's at Assisi and introduces
some traits of Giotto's style into
his compositions, which still reveal
the influence of Duccio, p. 27.

Nicholas III originally Giovanni
Gaetano Orsini (Rome c.1210–
Soriano nel Cimino, Viterbo 1280),
pope. His pontificate (1277–80),
hostile to Charles of Anjou and
to his influence on Rome, devoted
a great deal of energy to the
artistic and cultural growth of
the city, pp.16, 17, 26.

Peruzzi, Donato, one of the
wealthiest bankers in Florence,
he had a family chapel built
in the basilica of Santa Croce in
1299: about 20 years later Giotto
was asked to paint its walls, p. 105.

■ Pietro Lorenzetti,
Birth of the Virgin, 1342,
Museo dell'Opera del
Duomo, Siena.

■ Giovanni Pisano, *Crucifixion*, 1301, pulpit of Sant'Andrea, Pistoia.

■ Simone Martini, *Apotheosis of Virgil, frontispiece of the* Commento a Virgilio di Servio, 1340–44, Biblioteca Ambrosiana, Milan.

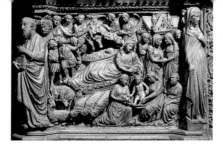

■ Paolo Uccello,
*Equestrian Monument
to John Hawkspear*,
1436, Santa Maria
del Fiore, Florence.

A DK PUBLISHING BOOK
www.dk.com

TRANSLATOR
Anna Bennett

DESIGN ASSISTANCE
Joanne Mitchell, Rowena Alsey

EDITOR
Susannah Steel

MANAGING EDITOR
Anna Kruger

Series of monographs
edited by Stefano Peccatori and Stefano Zuffi

Text by Monica Girardi

PICTURE SOURCES
Archivio Electa
Alinari, Florence
Elemond Editori Associati wishes to thank all those museums and
photographic libraries who have kindly supplied pictures, and would be pleased
to hear from copyright holders in the event of uncredited picture sources.

Project created in conjunction with
La Biblioteca editrice s.r.l., Milan

First published in the United States in 1999 by DK Publishing Inc.
95 Madison Avenue, New York, New York 10016

Giotto, 1266?–1337.
 [Giotto. English]
 Giotto. -- 1st American ed.
 p. cm. -- (ArtBook)
 Includes indexes.
 ISBN 0-7894-4851-3 (alk. paper)
 1. Giotto, 1266?–1337 Catalogs. I. Title. II. Series: ArtBook
(Dorling Kindersley Limited)
ND623.G6A4 1999
759.5--dc21 99-31207
 CIP

First published in Great Britain in 1999
by Dorling Kindersley Limited,
9 Henrietta Street, London WC2E 8PS

A CIP catalogue record of this book is available from the British Library.

ISBN 0-7513-0777-7

2 4 6 8 10 9 7 5 3 1

Printed by Elemond s.p.a. at Martellago (Venice)